COSMIC ART

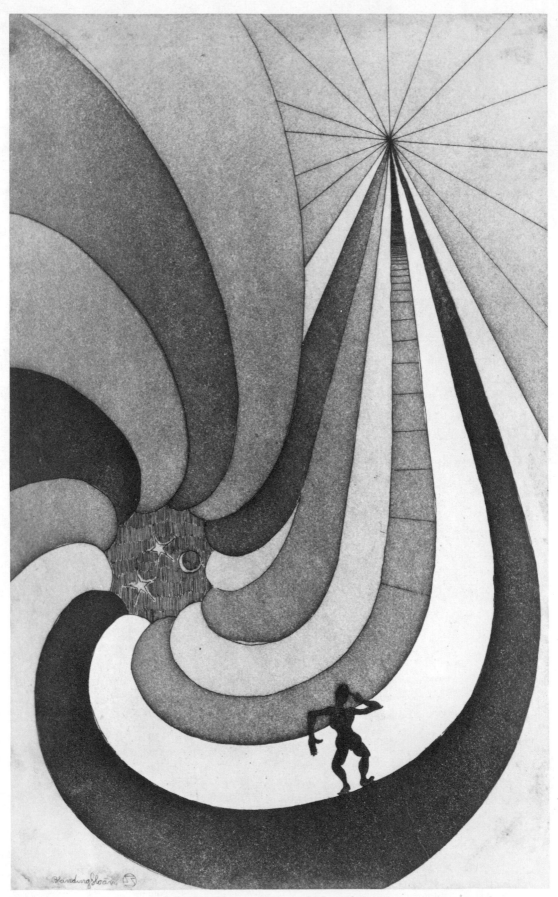

BLANDING SLOAN. *Two Infinities; Expanding and Vanishing*. Line etching and aquatint. 6¾″ x 10¾″. 1924.

COSMIC ART

Raymond F. Piper
and Lila K. Piper

Edited and with foreword by Ingo Swann

HAWTHORN BOOKS, INC.
Publishers / New York

It seems to me that infinity is usually visualized as receding into distant space and time toward nothingness, somewhat in the manner of a railroad track seemingly converging to a point in the distance.

Precedent-minded man, painfully trudging his self-inflicted way, conditioned attention fixed on the vanishing point, seldom has the perspicacity to shift his vision; to take his nose off the point of the pin long enough to become aware of and become part of the eternal stream that is ever expanding, continually approaching the encompassment of all things, all space, all time . . .

Blanding Sloan

CONTENTS

LIST OF ILLUSTRATIONS *ix*

FOREWORD *xiii*

ACKNOWLEDGMENTS *xxi*

1 Cosmic Genesis 1

2 Star Gazers 21

3 Dynamism of the World 41

4 The Universe and We 63

5 Beyond and Beyond 101

NOTES 141

SELECTED BIBLIOGRAPHY 143

INDEX 149

ABOUT THE AUTHORS 153

LIST OF ILLUSTRATIONS

COLOR PLATES (*following pages 10 and 42*)

1. Gerardo Dottori. *Flight Over the Ocean*
2. Louise Janin. *Isabelle de Castille*
3. Krishnalal Bhatt. *The Golden Purusha*
4. Krishnalal Bhatt. *Aspiration,* Fruition, *Illumination,* and *Transformation*
5. Gerardo Dottori. *Fragment of a World*
6. Louise Janin. *Assault*
7. Erwin Dom Osen. *A Planet to Die Away* and *The Divine Omnipotence*
8. Emil Bisttram. *Creative Forces*
9. Einar Jonsson. *Morning*
10. Columba Krebs. *The Vortices of Outer Space*
11. Hubert Stowitts. *Antahkarana*
12. Maulsby Kimball. *Trial by Fire*
13. Philip Moore. *Idol of America* and *Aspiration*
14. Elizabeth Farkas Brunner. *The Mahatma in Deep Meditation*
15. Ruth Harwood. *Ascendent Flame*
16. Faith Vilas. *Necromancy and Nativity*
17. Stan Baele. *Death*
18. Columba Krebs. *The Human Realm* and *The Universal Kingdom*

ILLUSTRATIONS

FRONTPIECE. Blanding Sloan. *Two Infinities: Expanding and Vanishing* ii
1. Conrad A. Albrizio. *Landscape* 2
2. Max Bill. *Unlimited and Limited* 5
3. Morris Graves. *What does it now pillar apart? No.* 7
4. Anna H. Allen. *Radiation (Sun Center for Meditation)* 8
5. Clint Cary. *Glorious Perception* 9
6. Géla. *Awareness* 13
7. Einar Jonsson. *Essence* 14
8. Louise Janin. *Enchainment* 16

9. Emil Bisttram. *At-One-Ment* 17

10. Joseph Heil. *The Ascending Self (The Rising Soul)* 18

11. Pierre Maluc. *Apex* 19

12. Agnes Pelton. *Star Gazer* 22

13. Agnes Pelton. *Illumination* 25

14. Agnes Pelton. *Orbits* 26

15. Agnes Pelton. *Future* 28

16. Johannes Molzahn. *Memoria in Aeterna I* 31

17. Mykolas Konstantas Čiurlionis. *Sonata of the Sun, Andante* 33

18. Mykolas Konstantas Čiurlionis. *Rex* 34

19. Joseph Earl Schrack. *Birth of an Idea* 35

20. Jeanne Miles. *Polyester Sphere #2* 36

21. Alexander Archipenko. *Exaltation* 37

22. Joseph Earl Schrack. *Germs of Inspiration* 39

23. Gerardo Dottori. *Dynamism of the World* 42

24. Michael Orogo. *And There Was Light* 46

25. George Graham. *The Morning of Creation* 47

26. George Graham. *And Spirit Moved on the Waters* 48

27. Mario Radaelli. *The Flower* 49

28. Mario Radaelli. *The Gods* 49

29. Henry Valensi. *Air Symphony* 50

30. Victor de Wilde. *In the House of the Lord Forever* 54

31. Edmond Van Dooren. *The Winged Eye* 55

32. Philip Perkins. *Guardian of the Planet* 56

33. Buell Mullen. *Man's Search for Reality* 57

34. Marina Nuñez del Prado. *Cosmic Mother* 58

35. Faith Vilas. *The Morning Stars Sang Together* 59

36. Victor Mideros. *Cosmic Consciousness* 60

37. Terrence Duren. *Man Inherits the Earth* 64

38. Morris Graves. *The Individual State of the World* 66

39. Philip Moore. *Groping* 67

40. Ivan Meštrović. *Supplication* 70

41. Marina Nuñez del Prado. *Carryin' Life's Burden* 71

42. Kenneth Callahan. *Man, Time, and the Machine* 72

43. Henri Frugès. *War* 74

44. Bernard O. Wahl. *Gold* 75

45. William Ward Beecher. *Dead End* 76

46. Blanding Sloan. *The Penalty of Genius* 77

47. Frederick Haucke. *Phrenic Universe* 79

48. Erwin Dom Osen. *Being* 80

49. Alice Harold Murphy. *Fear* 81

50. Charles Sims. *Lo, Here Am I* 82

51. Frederick Haucke. *The Black Shape of Madness* 83

52. Paulina Peavy. *Death* 85

53. Pierre Maluc. *Disincarnation (Death)* 86

54. Elizabeth Farkas Brunner. *Cosmic Beginning. Death—Darkness to Light* 86

55. John Farleigh. *In My End Is My Beginning* 87

56. Juanita Marbrook-Guccioni. *She Had Many Faces* 88

57. Pierre Ino. *Déchéance: Death and Resurrection* 89

58. Lorraine Starr. *Life, Death, and Transfiguration* 90
59. Gustav Wolf. *Cosmic Architecture* 91
60. Henri Frugès. *The End of Humanity* 93
61. Leo Katz. *Metamorphosis 1942* 94
62. Reva Remy. *Spiritual Gestation, Struggle for Light* 95
63. Einar Jonsson. *Deliverance* 97
64. Sylvia Leone Mahler. *Redemption* 99
65. Buell Mullen. *Youth Seeks the Far Galaxies* 102
66. Nicholas Britsky. *Floating Shapes #2* 107
67. Jean Lafon. *Le Mur du Monde (The Wall of the World)* 108
68. Willy Jaeckel. *Creation* 109
69. Willy Jaeckel. *Evolution* 110
70. Willy Jaeckel. *Illumination* 111
71. Blanding Sloan. *Mother* 112
72. Blanding Sloan. *Walk through the Gates* 113
73. Sylvia Leone Mahler. *Alpha* 116
74. Sylvia Leone Mahler. *Omega* 117
75. Sylvia Leone Mahler. *Magnitude* 118
76. Gustav Wolf. *Presence* 120
77. Helmut Zimmerman. *Towards an Archetypal Anatomy of the Soul* 121
78. Ethelwyn M. Quail. *A God of the South Pacific* 122
79. Dane Rudhyar. *Avatar* 123
80. Serge Ponomarew. *Trinity: Christ* 125
81. Serge Ponomarew. *Trinity: God the Father* 126
82. Serge Ponomarew. *Trinity: Holy Spirit* 127
83. Leo Katz. *Portrait of William Laurence, Science Editor of the New York Times* 128
84. Pierre Ino. *Cosmic Visitors #4* 129
85. Pierre Ino. *Cosmic Visitors #5* 129
86. Louise Janin. *The Marriage of Fire and Water* 130
87. Margaret E. Martin. *Release* 131
88. Ruth Harwood. *Beyond the Stars* 132
89. Parmanand S. Mehra. *Cosmic World* 133
90. Alice Boner. *Creative Evolution* 134
91. Bernard O. Wahl. *Aurora Borealis* 136
92. Jean Picart le Doux. *Man and the Universe* 137
93. Emma Lu Davis. *Cosmic Presence* 139

FOREWORD

In spite of all that has been written about it, art remains a curious thing. It is a drama whose scenario of governing values shifts inexplicably, mysteriously, almost always beyond the comprehension of the ordinary mortal. And often these values are so fleeting that the contemporary sociologist finds it difficult to grasp them long enough to dissect them before they disappear into a forgetful past, to be quickly replaced by new values that drift by and recede equally swiftly.

At any rate, this is the scenario that best describes the modern art movement, and certainly the art of the last twenty years. At various times in the past, art endured longer before it was replaced by evolving or revolutionary forms. The modern cadence of new forms, new messages, new ideas of art has accelerated until each art season of shows and museum exhibitions has brought startling annual shifts in form and fashion. Some of these pleased the onlooker, some irritated; almost all receded and are left to the future historian to place in some sort of significance.

This cadence also has increasingly driven ideas of art far away from the human awarenesses of the intangible. It has forced art toward the hard objective exterior worlds, those perceived and appreciated solely by and via the senses. In this wise, recent art has become preoccupied increasingly with form alone, and indeed any novel change in form has sufficed in many cases to constitute the ultrafashionable in contemporary art. It would have to be held, of course, that this recent trend has not been without merit in some cases. Regrettably, however, some of this art will not persist as valuable expression even though it has been given vast space in the media and art annuals. Far more unfortunate is the fact that this cloying search for novel form—reflecting what can only be called the materialistic approach to vision

and imagination—has served to act as a juggernaut of suppression over the vast human realms of the subjective, the transcendental, the mythic, the metaphysical, the parapsychological and the psychic, and even the religious.

This juggernaut, and its inevitable and frequent outcomes of sterility and abortive trends, has not altogether gone unnoticed. The protests have been many and varied, and many of these protests have reached publication. The critic, the collector, and the curator have found themselves "embattled"; the arts have been "in crises," and the "culture gulches" have widened. But, above all, the intuitive human, seeking something beautiful to respond to, has been left high and dry in the aesthetic aridness that has come to characterize the greater portion of today's art.

If the subjective visions of the inner man have found themselves out of place in relation to contemporary artistic values and standards, they have nevertheless suffered to develop out of sight of those powerful curators and critics who have looked askance on such departures from the materialistic norms. And in retrospect, this underground growth of artistic expression in the transcendental, the psychic, and the metaphysical can be seen to be not unmighty, but rather grand and poignant, deeply meaningful, and of vast importance to modern discovery in the realms of extended human consciousness.

There is always something subtle flowing and thrilling through the limited sensuous consciousness of the human being, something that moves contrariwise and adjacent to what eyes can see and ears can hear. Those who seek to limit their possibilities to what their senses perceive have lost themselves to the perceived world, a world that often is cruel and unyielding in its limitations. But before the grand inner man, that humanistic potential that can transcend physical limits via imaginative, visionary, and paranormal perceptual qualities, the walls to consciousness inbuilt in the physical universe drop away and disintegrate in trails of cosmic dust, infinite pathways that sparkle before his supranormal inquiring mind.

How it is exactly that these barriers are human-born in the first place and how they drop away in certain individuals remains yet to be discovered. But the fact that they do at times drop away is today no longer contested; the sciences of consciousness continue to verify this premise. It is worthy of thought that if a person begins merely to be curious about the universe beyond immediate sensual perception, in all probability the limiting walls of material consciousness have gained a few cracks. Such a person senses or glimpses the potential beyond physical senses and no longer exists as a slave to his body and the external world. In the thousands of reports of such shifts in consciousness, a sense, a portent of mental and psychic liberation, is always intuited.

Perhaps the individual finds himself confronted with even more awesome mysteries than he must deal with in the physical universe; but once the dice of the infinite fall in his consciousness, life is never again the cloying prison demarcated by the solely physical.

It is because of such a moment in the life of Raymond Piper that the contents of this book were collected and assembled in the meaningful form here presented. In Paris in 1920, the then famous but now almost quite for-

gotten Independent Artists' exhibition was on view at the Grand Palais, an exhibition that included some four thousand artistic works. Piper, in his notes, wrote that the jumble of eccentricities was unimaginable, and that the works were mostly banal, fantastic, infantile; and if some were masterful, he was nonetheless overwhelmed by the lack of congruity. Among the four thousand works an inspirational quality seemed to be missing.

As he was about to leave, he noticed a painting that, he said, changed his life.

He describes it as a painting some four by two feet, from which, in the bottomless abyss of the foreground, streams of color flowed up and over a wide ledge, like a waterfall in reverse. Near the top, the color bands receded and converged toward an invisible point far beyond the frame.

> I found I was contemplating a prism without beginning or end. A pure, cold mathematical idea became incarnate, warm, and glowing before my astonished eyes. It generated in me a strange joyful illumination, a warm feeling of an aesthetic conversion. I became keenly aware of color for the first time, and of the *cosmic* in art.
>
> In a sort of expansive explosion, I saw the enchantments, the adventures, the possibilities of color patterns. Most importantly, I reasoned eventually that if one artist could so successfully embody a profound metaphysical abstraction in eloquent pigments, then other artists might also objectify their philosophical and religious insights.
>
> At the same time, it was clear that the effect of delight and illumination requires a style that communicates feeling, and that the distinctive contribution of the artist is the creation of significant forms. I determined to find out if there were other artists who were working along such masterful insights.

The experience was never forgotten. Joined by his wife, Lila, an educator, Dr. Piper sought to determine if there were living artists who were artistically portraying their philosophical, religious, and later, psychic, insights in aesthetic forms. In thirty years of research, the Pipers were able to amass interviews with over two thousand artists from sixty-four countries. The Piper records include over twenty-five hundred photographs of art works, supported by statements, personal histories, and inspirational writings from most of the artists interviewed.

The backbone of this research centered on an unconventional questionnaire that, in addition to biographical material and educational background, asked the following six questions in search of an aesthetic of cosmic art:

1. Can you formulate the special symbolic meanings in your work?
2. Please put down a frank, clear, compact statement of the mood, sentiment, idea, or vision which you experienced.
3. Please name any religious, metaphysical or occult society, organ-

ization, or movement in which you are, or have been, actively interested, and indicate its effect upon your viewpoint and art.

4. If you have had any extraordinary mystical, aesthetic or psychic experience, or conceptions of God, beauty, or the spiritual life, which might explain your creations, would you kindly summarize them?

5. Please state briefly your idea of God, of man, and of man's goal or purpose in existence.

6. If you have formulated any striking or illuminating aphorisms or maxims about art, religion, or God, please record them.

While numerous art forms have come and gone since the turn of the century, psychic, transcendental, and spiritual art has flourished without overzealous applaudings from the art establishment. These artists, termed "cosmic" by the Pipers, have worked alone and apart. As a result of for the most part being denied access to the usual showing places, they have not formed an integrated art movement. Their work, therefore, stands unusually fresh, individualized, and undiluted by establishment critical standards.

As a group, the psychic and transcendental artists interviewed by the Pipers respond to the historical concept of aesthetics, that is, an involvement with the nature of beauty and with the laws governing the expression of psychic and subjective beauty in concrete forms.

At least 850 artists in many different countries attest to the existence of common aesthetic principles underlying the portrayal of subjective awareness, and most attest to the important underlying theme of the expansion of awareness. Yet another of the sustaining characteristics common to most of these artists interviewed by the Pipers is the magnitude and personal responsibility by which they view the goal of the artist and the meaning of art.

In their involvement with the intangible concepts, transcendental artists seek to reveal their expansive mental and spiritual experiences, their inner and subjective as well as psychic awarenesses—those universes beyond the concrete where images, emotions, and infinite but familiar understandings of ideas endlessly unfold. In considering any of the transcendental peripheries, the mind or the spiritual awareness of self does not float on a stream of temporal or visual concrete conclusions but does defy space and time, as well as usual arrangements of matter and energy.

The arena of "mind" in which this type of creation takes place, this "space of mind," has dimensions that consist of all imaginable basic kinds of values that the human spirit—the immortal element of the human—might wish to realize. We know and generally acknowledge that the universal concepts that illuminate the greatest reaches of even concrete realities are metaphysical concepts. And these are the most general and fundamental predicates of being, without which life would become exceedingly dull.

It might be said, succinctly, as the Pipers do, that metaphysical categories are the beams in the building of existence. People in general, and the artists represented in this book in particular, have in their "inner spaces" become

involved with discovery in the various metaphysical categories they have become aware of.

Considering the modern abysmal ignorance of the magnitudes of the human mind and spirit, anything constituting a psychological interpretation of this book and its contents would probably be a fruitless and nonilluminating task. And if during the last half-century it has been the fate of the West to experience inundations of Eastern spirituality much of this esoteric ancient spirituality has served to create treacherous viaducts, mainly through false and incomplete understandings of those seeking to compensate artificially for the inherent limitations in Western concepts of psychology and spirituality. If, therefore, certain of the artists represented in this book have found encouragement by absorbing Eastern concepts, the Eastern forms of spirituality alone are not adequate to account for the magnitudes of the artists in toto.

There is inherent in the work of the artists represented here a certain withdrawal of the center of psychic gravity from the external worlds, including the worlds represented by the past, towards an immanent future, where the mind and spirit of the human will soar beyond limitations both of things physical and of present ideas about thought itself. This withdrawal represents not a retreat to old ideas of mind and spirit, but an encompassment of them with a strange, often befuddling, but certainly exciting drift to the frontiers of mind and awareness themselves.

This drift seems to want to approach a new consciousness that perhaps is the heritage of the future man, but that can, indeed, be touched upon by those in the present, and has been so touched by many in the past. As the Pipers indicate in their notes, this consciousness appears to be spread out, like a magnetism, a field of awareness always immanent in the selfic sky. This cannot be expressed in terms of three dimensions alone, since it seems to belong to a higher, more expansive order.

It will be observed that much of the art represented is indebted to the modern movements of abstraction and surrealism, as well as to others. It is usually accepted that the nonfigurative, abstract movement began as a rebellion of painters against the realistic portrayal of natural objects, and that they liked to call their revolt purification and liberation. They rejoiced in being released into the vast world of forms and colors. And freedom is indeed intrinsic to that familiar universal power of mind called abstraction.

This consists of man's marvelous native capacity, through selective attention, to pull out of his available environment whatever materials he needs for constructing anything he wants from golf balls to Gothic cathedrals and metaphysics. But, actually, abstraction was not new to the nonfigurative movement, being found in art in every age.

As Raymond Piper wrote, unfortunately many of these nonfigurative artists usually could not see the true nature of their products for lack of a clear philosophy of purpose. This lack lies in the nature of abstraction itself; it is a method or process, not an end or an ideal. Without a significant human goal, such art becomes chance and accident, tending to produce the wildest monstrosities, vacuities, nonsense, and junk in the history of art.

To abstraction, the mature artist might bring deep vision and understanding, a more solid philosophy, and a determination to use accumulative mastery of form and color in portraying important human values. These creations may echo the structures and textures, the laws and agents of nature itself, often as revealed by the marvelous instruments of modern science. But they should express also the new emotions, problems, and aspirations of contemporary man. And the abstract artist may recall that abstraction alone can be a path away from as well as towards human reality.

The surrealistic artists sought to explore and express subconscious mysteries, feeling that the subconscious has symbolic language that can be universal. It is a vocabulary of great vital constants: sexual fantasy, death, morbidity, and the enigmas of space and time. All these vital constants are repeatedly echoed in our very being. But, in the total surrealistic output, demonic themes have predominated over the intimations of the infinite and the divine. As such, surrealists usually possessed no lofty or liberating insights into the nature of man.

During the last century, three kinds of human interests have resulted in three types of dominant styles of art. These interests have been in nature, in man himself, and in beautiful patterns of forms. First, one may identify *depictive art*, art that is representational, figurative, descriptive (realism, naturalism, classicism, impressionism). Second are the *emotive arts*, the subjective, emotional, humanistic, and dramatic (romanticism, expressionism, surrealism and "pop"). Third, there would be *morphotic art*, "morphotic" being from the Greek *morphe*, meaning "form." These are abstract, geometric, nonfigurative (cubism, nonobjectivism, constructivism, abstract expressionism, "op," and so forth).

To these a fourth type of art can now be added, the *synthetic art* form. "Synthetic" is here used in the constructive sense of characterizing the mental or spiritual and psychic activity of putting together some new individual thing. Its synonym, "integral," likewise characterizes any individual whole in which a variety of components has been suitably harmonized or blended. In synthesis, the integrating creative self combines and makes use of the best of each of the other three general art sources mentioned above, seeking to construct new orders of awareness itself of the psychic, of the paraphysical, of the cosmic in self and in things. Synthetic art, therefore, is an ordering of form towards revelation of idea, of awareness, of thought, of experience beyond form.

This book grew out of the experiences, decades long, of Raymond and Lila Piper, experiences in science and education, in theology, in metaphysics, in cultures of other countries, all these joining and ending in the vast territories of aesthetics. They discovered how great art can communicate, creating deep emotions and insights.

In October 1961, barely two months before Raymond Piper passed on, the Pipers noted:

The world today is witnessing unprecedented growth in both space and spirit. In the realms of space, our vision is reaching out into the magnitudes of the universe and deep into the minutiae of electronic energy. While growth of our knowledge of space is most dynamic and obvious, there is also in the world today notable discovery and growth in the realms of spirit and the psychic. Yet the wonders of exploration into the vast outer universe must be matched by discovery of even greater wonders within the hidden powers of the human self.

These wonders, of whatever kind, always come as a personal experience, as the discovery for oneself of a new distance in space or a new dimension in spirit, as the discovery of enduring values and therefore of cosmic security.

And now, five decades after Raymond Piper began his search for metaphysical artists, stalwartly supported in the following years by his wife, Lila, here are but a small part of the Piper researches. But it is a part from which many will find an echo bouncing around in themselves; an echo that comes alive beyond physical boundaries, a sound that hums and encourages, a timbre that intimates the cosmic in every man.

INGO SWANN

Acknowledgments

It is perhaps apocryphal that I first met Dr. Raymond F. Piper in 1933 when he was traveling in the Orient to study world religions at their source. He had three primary or principal areas of philosophic interest: metaphysics, aesthetics, and living religion. During the years of our life together, from our marriage in 1940 till his sudden death on December 31, 1961, he was constantly planning, preparing, and working to complete this book on cosmic art.

Cosmic Art represents the blending of his three primary interests, and it was the culmination of his professional career. Since I had worked closely with him through the years, interpreting pictures, classifying them, and corresponding with artists, I felt impelled, after his death, to complete the work to which he had been so completely devoted.

I acknowledge with deepest gratitude the cooperation of all those artists whose works are represented as well as extending my appreciation to all those artists—and they are legion—whose works could have been included, except that a selection had to be made. I know there are many other individuals to whom Dr. Piper would surely have wished to express his appreciation had he lived to finish the book, but records are no longer in existence to enable me to cite them. My gratitude is nonetheless sincere.

One artist, however, must be named because it is due to his complete dedication and continued effort that *Cosmic Art* has been published. Ingo Swann reorganized all the material and in many and various ways publicized it. His knowledge and experience proved to be invaluable. He became a true and dedicated disciple of cosmic art. He wrote essays and gave numerous lectures, devoting most of seven years to its dissemination. And, finally, it was

Ingo Swann who was able to make the necessary arrangements for this book's publication. This very brief public acknowledgment is just a token expression of my deep appreciation and sincere gratitude for all that he has done to bring *Cosmic Art* to the public.

 Special thanks must be extended to those museums and institutions that have made possible reproduction of artistic work in their possession: the Sri Aurobindo Ashram, Pondicherry, India; the National Einar Jonsson Museum, Reykjavik, Iceland; the Čiurlionis Art Museum, Kaunas, Lithuanian Soviet Socialist Republic; the Newark Museum of Art; the Cleveland Museum of Art; the Prints Division, the New York Public Library; the Theosophical Publishing House, Adyar, Madras, India; the Lewis Foundation; and the Museum of Modern Art, New York. Special thanks are also due to Marion Willard of the Willard Gallery, New York.

LILA K. PIPER

1

COSMIC GENESIS

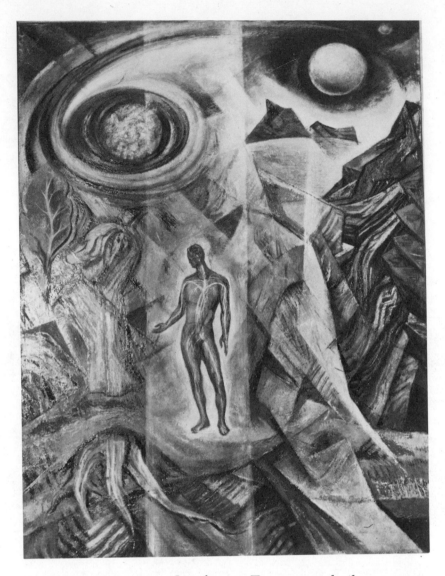

1. CONRAD A. ALBRIZIO. *Landscape.* Tempera and oil on canvas.
36″ x 48″. 1946.

I have had moments of revelation when the problems of life as such
presented no mystery.

Conrad A. Albrizio

Mankind is entering a space-conscious age, a cosmic age, in which his conceptions of space and time are becoming immensely enlarged in three fields or directions: in stellar galaxies, in the intricacies of the atom, and in the psychic, religious, and aesthetic realms of human awareness.

Consequently, cosmic artists face unprecedented challenges to create works that communicate the emotional significance, truth, and beauty of these expanding vastnesses in their countless aspects.

Many people are partial to fine works of cosmic art, because their intrinsic delights are portals that invite them to make excursions into spaces of the psyche—spaces beyond physical things, spaces of freedom, immensity, and sublimity.

Such spaces, however, remain as ideal infinities, vague vacuums, until a thinker, prophet, or artist establishes dimensions and structures in them. The endless problem of the cosmic artist is to populate mental and psychic spaces with images of beauty and insight.

Often in viewing the color masses of many contemporary paintings and assemblages, one may feel confined, tied down, caged in. The edges are too near, the masses are brutally physical, and the color planes are too shallow. Such paintings force their viewers into cramped corners and unintelligible chaos.

Some human beings with spacious and orderly minds may feel repelled by a kind of effrontery or indignity in art of this constraining kind. Some want an artistic work to impel them to use their minds imaginatively, constructively, spiritually, or joyously. Standing before an autonomous patch of color or a jumble of shapes that speak only of hardness or crassness, it is easy to feel restless, almost as if one were flying in a doomed airplane.

Let us postulate that mental space, or the field of human consciousness, has dimensions and that these dimensions consist of infinite time and space, or spiritual and psychic ideal human values. These values are the basic aspirational directions in which the human self may operate, may retreat or expand. Each dimension is a sort of thread, a strand the development of which is indispensable for a strong, balanced, and joyful life.

There are multitudes of definitions of the self. Out of these multitudes, those definitions that suggest magnitudes undreamt of in the self are perhaps the most desirable. The well-known philosopher E. S. Brightman has suggested that "personality is not a fixed and complete entity that can be labeled and preserved in a museum. It is a life—a changing, actively functioning experience in constant interaction with its environment. . . . Personality is a system of interacting processes in many dimensions" (1).

Another modern philosopher weighing definitions of the self, Paul Tillich, indicated that "man does not consist of parts, but is a multidimensional unity, and these dimensions are sent out in many directions" (2).

The strand of goods called beauty is one of the cardinal dimensions and directions in which the human self expands.

The cosmic artist strives to incarnate the chief human values, as he sees them, in satisfying forms. To do this, his awareness can be seen to move in multidimensional directions.

I do not produce religious art in the sense of religion, but I am doing works that are in a certain way so elementary that they belong to a prereligious sphere.

Max Bill

2. MAX BILL. *Unlimited and Limited.* Oil on canvas. 41″ x 44″. 1947.

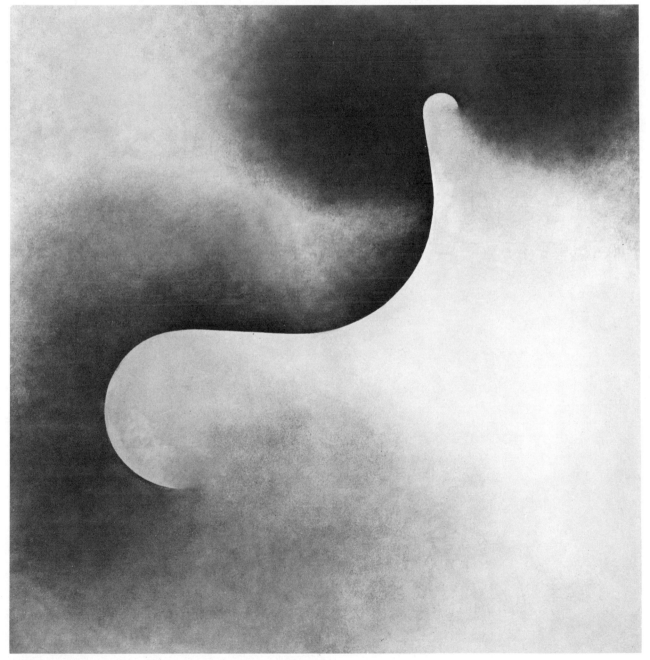

3. MORRIS GRAVES. *What does it now pillar apart?* No. 2. Tempera. 10" x 10". 1947. Collection Mrs. Claire Rumsey.

What does it now pillar apart? speaks of that ultimate need, the non-relative. . . . It is that which pillars-apart the conscious mind from the superconscious mind, the differentiated from the undifferentiated—that polarity that is indestructible within time.

Morris Graves

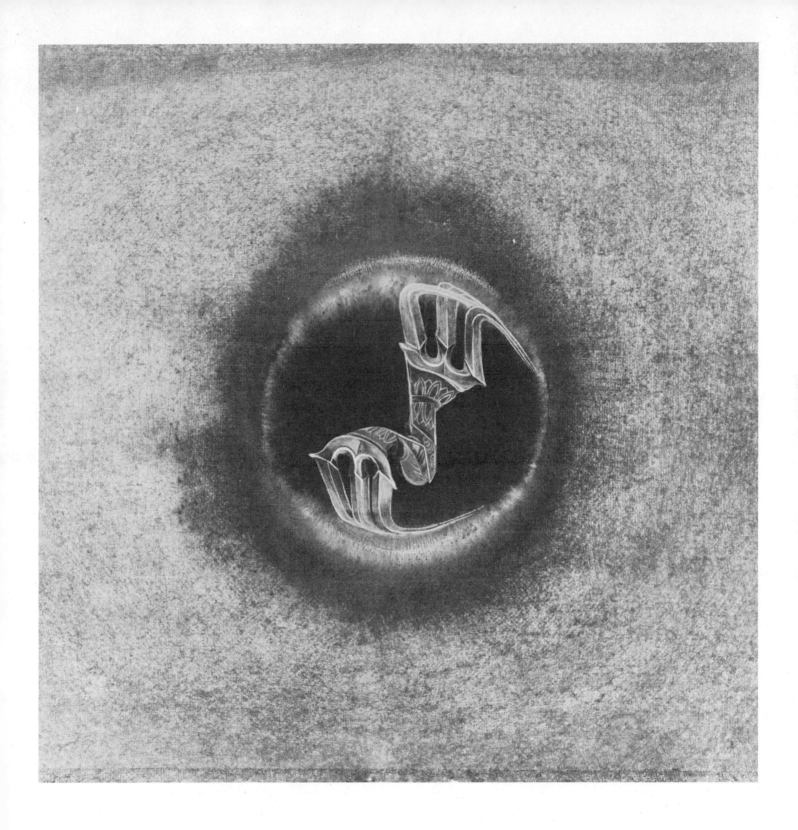

4. ANNA H. ALLEN. *Radiation (Sun Center for Meditation)*. India ink on paper. 10″ x 12″. 1937.

Silently I listen and present my problem and wait for an impression—a possible solution arrives that is acceptable and understandable to me and peace through the calmness of mind results.

Anna H. Allen

5. CLINT CARY. *Glorious Perception*. Tempera and metallic paint on paper.
28″ x 34″. 1952.

I never studied art. I became a painter because of my inability to describe in words that which I could only visualize in color and form. Gradually I became aware of the expanding universe. The true artist is the cosmic explorer. Cosmic art is the fluid method that is capable of expressing ever-expanding concepts—it is a spiritual language.

Clint Cary

All art is cosmic in the metaphysical sense of existing in a definite setting in the total universe. A work of cosmic art originates when an artist expresses his consciousness or awareness of some significant relationship or linkage to the larger forces of unseen realities. It becomes "religious" when its creator experiences a new or more intensive feeling of reverence, worship, or of mystic or psychic union.

Nature lovers, transcendental poets, and religious and psychic artists testify to this feeling of an unseen existence and spiritual or psychic comradeship that they seek to objectify and enhance through their artistic creations.

And also many great scientists, such as Albert Einstein, bear witness to a higher level of religion than one of fear or morality. They sense a divine plan in the wondrous order and beauty in nature, in the solar system, and in man's abilities to harness the elements for his own use.

In conversation, in correspondence with many great artists in pursuit of creating this book, and in published articles, many artists expressed their convictions concerning the obvious linkage between art and an awareness of higher things, things beyond the physical senses.

They indicated a general metaphysical goal, that of striving toward acting in unison with the soul of the universe. Many provided elegant psychic insights, and many others demonstrated in art and in correspondence their preoccupation with far-reaching human involvements.

But all evinced a basic sense of religious enterprise in the sense that—although the word admits to the widest of interpretation—has to do with what is most vital in the feeling, direction, awareness, belief, and performance of every human being.

In correspondence, for example, artist Lyonel Feininger considered all his paintings to be a religious art of purification, enabling him to obtain clarity and to overcome emotional desires. Sculptor Ivan Meštrović indicated that no work of art could live or come into existence without some remote religious conception (3). And the famous art historian André Malraux has said, "Art catered . . . for those rare moments when, in contact with a mediating Presence, men have glimpses of the meaning of the universe" (4).

In one way then, the relationship of cosmic beauty in art and things beyond man's immediate senses is at once a metaphysical, theological, aesthetic, and technical problem.

Yet, cosmic artists are deeply concerned with man's origin and his destiny, with his adjustments to nature, neighbor, and problems of increased or decreased awareness, with security and growth in the universe.

To match the seriousness and sublimity of these themes, there is demanded a grandeur of form and a mastery of technique; the perfect union of form and idea that is the goal of fine art because it is the condition of the fullest consummation in artistic consciousness.

The fruit of this truly awesome demand has been some of the greatest works of art created by mankind. Works that deal effectively with the longings just mentioned may be called cosmic art, a unique blend of aesthetic, psychic, metaphysical, and religious insights. Cosmic art is emphatically transcendental, often psychic, and usually exhibits personal religious threads.

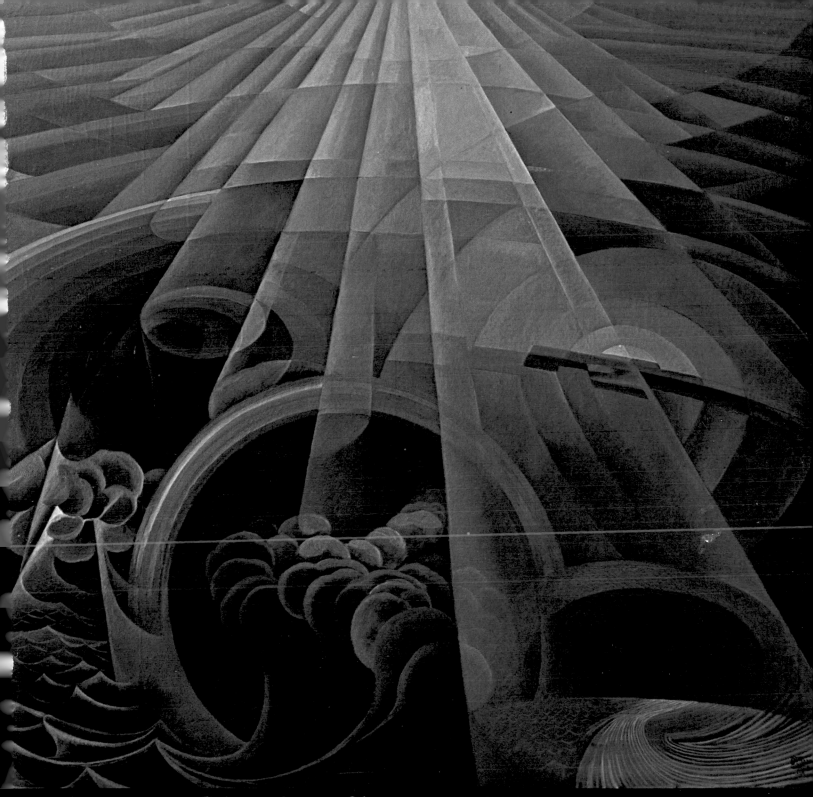

1. GERARDO DOTTORI. *Flight over the ocean.* Oil on canvas. 48" x 42". 1932.

2. LOUISE JANIN. *Isabelle de Castille*. Chrysolite. 135 cm. x 105 cm. 1949.

3. KRISHNALAL BHATT. *The Golden Purusha.* Watercolor on silk. 14½″ x 19½″. 1934.
Courtesy of the Sri Aurobindo Ashram, Pondicherry, India.

5. GERARDO DOTTORI. *Fragment of a World.*
Oil and tempera on canvas. 35″ x 45″. 1955.

6. LOUISE JANIN. *Assault.* Oil on canvas. 51″ x 67″. 1948.

7. ERWIN DON OSEN.
A Planet to Die Away (top).
Oil on canvas.
90 cm. x 90 cm. 1959.

The Divine Omnipotence
(bottom). Oil on canvas.
39″ x 39″. 1951.

6. GÉLA. *Awareness.* (Detail.) Polished terra cotta. 17″ high. 1951.

Visions are concealed in the subconscious and only come out slowly while the mind is actually at work. Desire and love for art are essential, as well as absolute stillness.

I shut out everything and don't think or plan at all. Then, suddenly, it is there, all by itself.

Awareness, or watching, is concentration, really seeing face to face, seeing the other and seeing oneself.

Géla

7. EINAR JONSSON. *Essence*. White plaster of Paris. 44" high. 1939. Courtesy of the National Einar Jonsson Museum of Reykjavik.

Much of the art that will characterize the awareness of the future perhaps will interpret realities that are, like those pictured here, invisible to the natural eye of man and not yet apparent even to the powerful amplifying instruments of advanced science.

Since science involves more than ever-increasing amplification and precision of measurement, the scientist, as well as the artist, must be concerned with deeper ways of looking at nature. Art and science are in this way complementary, and cosmic insight is the catalyst vital to making fundamental progress in both. And creating panoramas of the realms and spaces of the psyche are the goals of cosmic artists; their perfection and success as artists in this novel field of aesthetics depends on their sharpening of psychic and spiritual faculties and the intuition of their adventuring minds.

The mystery of wisdom exhorts us to climb to those heights where there is a wide view over the land. There is a large expanse of land above us, which the heavens granted us, but which still lies undiscovered and unused.

Einar Jonsson

8. LOUISE JANIN. *Enchainment.* Oil on canvas. 44" x 36". 1947.

In this composition, logarithmic spirals—supreme cosmic forms—are mathematically controlled. I thought of a certain aspect of Celtic mysticism; one form, or life, or state growing out of another in an endless chain.

Louise Janin

The artist must be a philosopher, a psychologist, a student through his entire life. The search for knowledge, not only of one's craft but of one's self and of the world around, is necessary to his growth and to the maturity of his art.

Emil Bisttram

9. EMIL BISTTRAM. *At-One-Ment*. Pencil drawing. 12″ x 16″. 1936.

10. JOSEPH HEIL. *The Ascending Self* (*The Rising Soul*). Oil on canvas. 21″ x 13″. 1948.

The cycle of spiritual growth is forever recurrent. The seed ever is and never was not.

Joseph Heil

18

11. PIERRE MALUC. *Apex*. Scratched paper. 14½″ x 10″. 1954.

My drawings are dynamic, always in movement. They open windows upon a world that invites you to continue your endless trek into space and into spirit, evermore beyond and beyond.

Pierre Maluc

2

STAR GAZERS

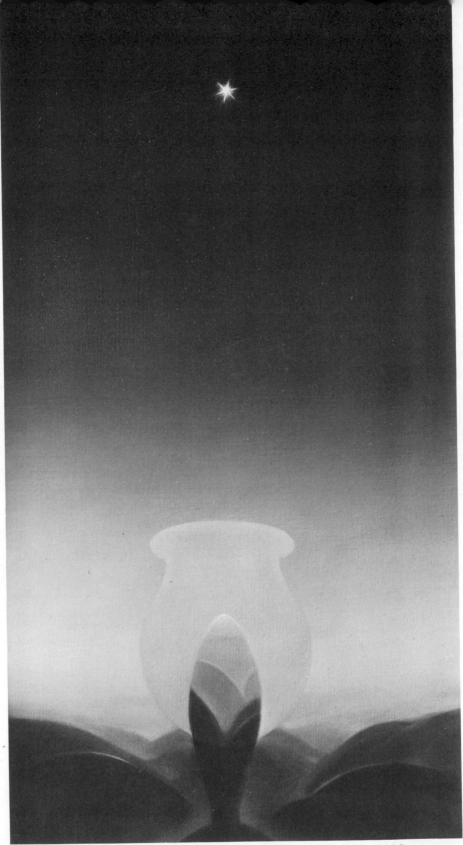

12. AGNES PELTON. *Star Gazer*. Oil on canvas. 16″ x 30″. 1929.
Courtesy of Mrs. Emma Newton Winchell.

Cosmic art should bring us something of what lies beyond the more personal mentally religious conceptions, some intimations from outer space, as also from the depths of our inner lives.

Agnes Pelton

Art that is cosmic reflects attempts of modern men and women to depict things that are really most meaningful, that are of vital importance to them in their progress through life: their struggles, temptations, emotions, joys, sorrows, beliefs, ambitions, their choices of life and awarenesses of choices beyond life itself.

The reproductions of art in this book present perhaps a prevision of the art of a cosmic age, an age when awareness and wisdom will be different than now. The selections and their textual discussions reflect an integral idealism that rejects the narrow notion that momentary sensation is justification for artistic creations. This idealism demands that works of art possess both beauty and significance, the sum of aesthetic delights and human values. Both beauty and significance are important to awaken human, civilized, psychic, perhaps even divine potentialities, and to bring real and lasting joy in art and life.

Excursions through this book may bring many surprises. Many illustrations, although executed decades ago, are novel and fresh. Few have been published before, and the total, coming from many countries, represents a world view of transcendental and psychic vision.

It is truly delightful, through the language of art, to discover distant kindred spirits and thus to enhance one's feeling of communication within mankind. Also, the statements of the artists may engender illuminating insights into the nature of art and of artists themselves, of man in the universe, and

of many things that current concepts and philosophies find difficult to consider.

So far as possible, the selections exemplify technical excellence and originality. At the same time, they communicate some of the most important concerns of modern man. Most works are symbolic, spiritual, psychic, and metaphysical; in short, they are cosmic.

The word "cosmos" is one of the most wonderful words in language. It is a grand and formidable name for everything, the orderly, harmonious *all* of reality. There is no true synonym for cosmos.

The English word cosmos comes directly from the Greek *kosmos*, meaning order, ornament, world, universe. It is a philosophical jewel that irradiates seventy-five English words. Its Greek form includes two qualities and generates two adjectives: "cosmic," pertaining to universal order or harmony and "cosmetic," adornment or decoration. Pliny's translation of the word was "perfect, absolute, and elegant world." Cosmos means the entire manifestation of spirit, the organized universe and man's awareness of it.

The use of such a familiar and generic word to characterize the art in this book may seem odd. But many art critics agree that it does define the frontiers and the problems of contemporary art.

Chaos is the opposite of cosmos. But chaos also appears to have its conditions. Yet the multitude of scientific laws demonstrate that order, in fact, usually prevails. It is an ordered universe, in spite of evident chaos.

Cosmic consciousness is *knowing* itself, the knowing of the innate order, the observation of chaos. In a sense, then, cosmic consciousness has no opposite. Its antithesis would necessarily have to be absolute isolation, but that is an impossible situation for any sane person or thing.

The radiant star as a messenger is a symbol of the sudden descent of transcendent light, answering through darkness the rising peaks of aspiration.

Agnes Pelton

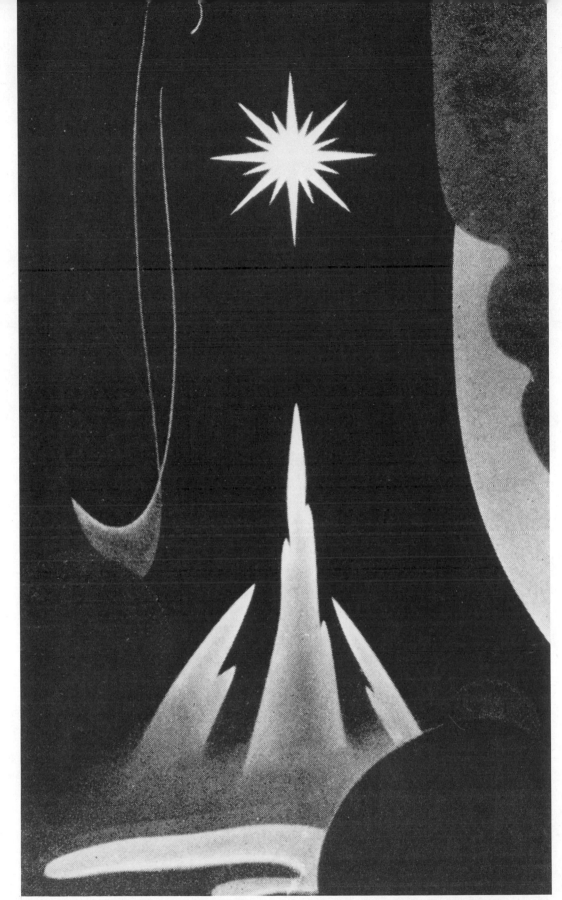

13. AGNES PELTON. *Illumination*. Oil on canvas. 27″ x 46″. 1930. Courtesy of
Mrs. John D. Graham.

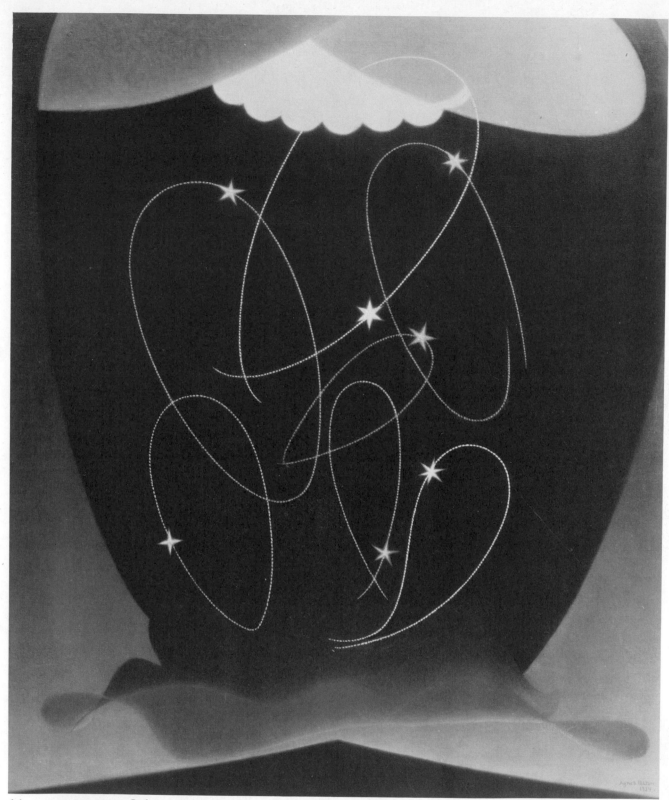

14. AGNES PELTON. *Orbits*. Oil on canvas. 30″ x 36″. 1934. Courtesy of Mr. Raoul Erickson.

Though art lends itself willingly to illustration of mental concepts and presentation of human and natural forms, art within its own field can contribute to the apprehension of spiritual life and the expansion of a deeper vision. Of all the arts, painting is the foremost in the use of color, having within its scope the possibility of the direct communication of its vibratory life, an essential element in light.

Paint, the most sensitive material substance in use for creative expression, can convey, under the painter's hand, his most delicate feeling and complete intention insofar as he masters its use. The personal choice of color, or impulse to its use, is the life and vitality of any painting; and in abstract expression this choice is simplified to intensity so that its higher vibratory voice can speak directly, as does sound in music.

The aim of these paintings over many years has been to give life and vitality to the visual images that have appeared to me from time to time in receptive moments—as symbols of fleeting but beautiful experiences. The forms and activities expressed are no doubt related to experience, but only as distillations and seen on that plane that is neither past nor future—perhaps aspects of both—where shadow may become as sound, and color enhance to power or light to radiation.

Agnes Pelton

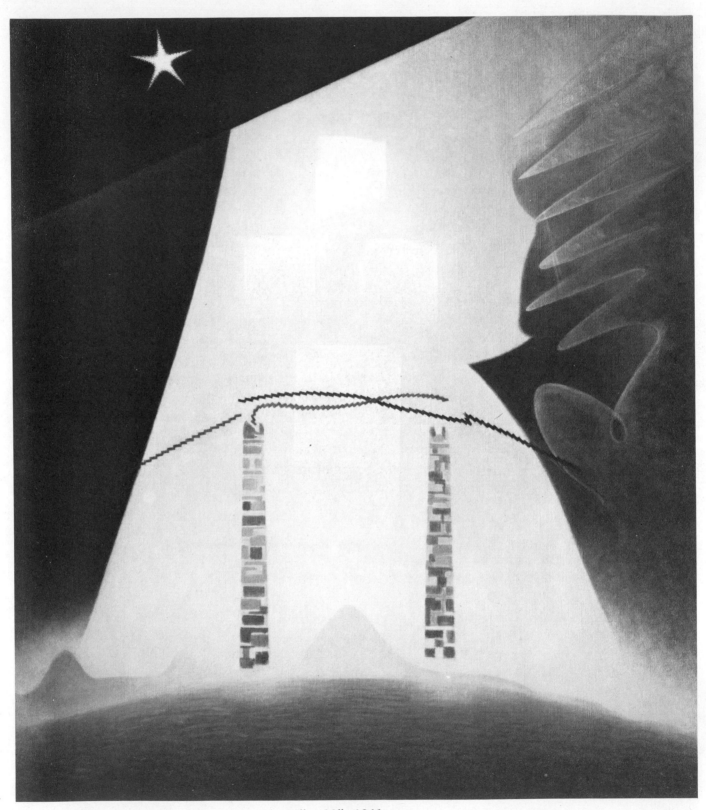

15. AGNES PELTON. *Future*. Oil on canvas. 26″ x 30″. 1941.

The great teacher William Ernest Hocking wrote, "When a person is lost, it is not because he does not know where he is—he always knows that—but because he does not know where the rest of the world is, the points of the compass, the wider landmarks of the region" (5). Everything can be known by interlinkings and multifarious relations that extend into abysses, to brims, and into infinitesimals of beings. Directly or indirectly, man is connected with everything else. Cosmic relationship expresses the fact of universal interdependence among particular things. To be is to be in relationship to all other things, and what counts is awareness of one's total involvement.

The essence of cosmic experience is a felt linkage with a larger universe than the mere shining presence of sensual experience. For some of us as finite beings, these infinite relationships become conscious or explicit; for the rest, they might remain silent, distant, only implicit. The well of possibilities, the inviting richness of growing things, is the idea that reality is infinity unfinished. Unfinished infinities, or unfinished awarenesses of infinities—this is the cosmic problem, the cosmic preoccupation; and it is dealt with artistically in many ways.

In *The Brothers Karamazov*, for example, Fyodor Dostoevsky describes the elation of Alyosha as he contemplated the fathomless vault of the soft shining stars and the slumbering earth.

> The mystery of earth was one with the mystery of the stars. Alyosha stood, gazed, and suddenly threw himself down on the earth. He did not know why he embraced it . . . he kissed it weeping. What was he weeping over? Oh! In rapture he was weeping even over those stars, which were shining to him from the abyss of space. There seemed to be threads from all those innumerable worlds linking his soul to them. He was trembling all over in contact with other worlds (6).

A drop of pigment or the hair of a brush are, of course, elements in the painter's cosmos, as are the stone of the sculptor, the sound of the musician. Cosmic experience, however, does not ordinarily refer to particular phenomena as such, but to the general laws, causes, supports, persons, values, or perspectives of things, especially to that all-pervading awareness that at once maintains and transcends all entities and events.

The identification of largeness in space or reality, in spirit or personality, requires a precious kind of judiciousness about causalities and values. The authentic cosmic artist wishes to create satisfying images of his feelings about entities and relationships that are of the greatest significance for developing himself and others. He intuitively knows how to distinguish spiritual grandeur from trivia.

All art that rests upon a spiritual process, whether this base be philosophical, psychic, or religious, is cosmic art because it envisages man's existence as absolutely tied into the preexistent cosmos, an emanation of a transcendent cause.

The cosmic artist must himself have a feeling or a sense of cosmic relationship. He must have something worthwhile to express. Cosmic art communicates a feeling of cosmic relationship, of universal linkage—an experience with which others may identify in media or in symbols that the viewer intuitively understands.

Universal linkage or nexus is thus the key to understanding cosmic experience, as the philosopher O.L. Reiser indicates when he says, "The term 'cosmos' is used to designate the weld of the visible manifest and the invisible unmanifest of the worlds" (7).

The chief contribution of the fine arts to self-realization is their power to enlarge the range of the emotions or values by which we live. Cosmic art especially enriches psychic, metaphysical, and spiritual values. Art is man's transformation of the world to expand his delight in existence and to promote his own self-realization.

Different artists approach this manifold problem in different ways. Emil Bisttram, for example, in describing his beautiful *Creative Forces* (color plate 8) indicates that the eye is symbolic of the spirit that is ever concerned with the structure and destiny of the universe, from cell to cosmic scheme.

In another way, Johannes Molzahn indicates that his painting *Memoria in Aeterna* (illus. 16) is the logical consequence of all his previous work and that the title (Eternal Memory) is self-explanatory. There was no special occasion for the occurrence of the underlying idea; the accumulated experiences of a whole life gave occasion to it.

I do not believe that man is but a social animal. Neither do I meddle in the whole unyielding controversy of whether or not matter or man's spirit shall have the prime lead. Neither matter nor spirit means anything in itself. It is important only that they meet each other in man.

Matter and spirit are inseparably interlocked. A perfect reciprocity prevails between both. No matter is of any significance without the spirit and the tools, tools that merely extend spirit, tools that convert matter. No spirit is of any significance without matter that manifests man's spirit. Both are in incessant communication, cooperation, correlation, striving for the fulfillment of their mutual harmony, striving for the optimum function.

Johannes Molzahn

16. JOHANNES MOLZAHN. *Memoria in Aeterna I.* Oil on canvas. 50″ x 59″. 1946.

Other artists sense and portray human involvements beyond physical perceptions. In describing her lovely painting *Orbits* (illus. 14), Agnes Pelton suggests that it portrays harmonious interweavings of lives or activities, that motion is expressed as one watches—the duration of time necessary for any complete expression, as in life, and beyond life. And in this way *Orbits* is akin to music. In interpreting *Future* (illus. 15), Pelton says that it is considered by some to be an occult painting.

> I do not indulge in occult practices, and so I do not know to what extent that might be true. Looking far ahead, a small conical mountain suggests hope or aspiration. Two columns or pylons of white stones are, perhaps, symbols of a tale that has been told. And the forms that bridge the pylons—I can't quite put it into words—indicate the forces or activities put into action by the tale in the past. As the pylons do not touch the ground, they are eventually impermanent. As with all my paintings, I am glad to have the spectator resolve the meanings, each in his individual way.

In *Rex* (illus. 18) by Mykolas Čiurlionis, an artist held by many to be the father of abstract painting, the artist, and perhaps the viewer, ecstatically loses himself in the whole world and sings his joy in rhythmic, prismatic movements. Vitalizing flames erupt from the depths of the earth and expand into the cosmos. In the heavens above, these forces receive the visual form of rex, who brings meaning, brightness, and order into the universe.

In *Sonata of the Sun* (illus. 17), Čiurlionis takes his visual metaphor to a time when nature is no longer represented in beautiful details but as a mysterious luminous whole. The painting's delicate tones suggest the infinity of light and the mood of a brooding mysticism, a pantheistic tranquility.

Joseph Earl Schrack, writing about his *Birth of an Idea* (illus. 19), feels that it is man's supreme privilege to give himself towards expressing a self-conceived cosmic idea. To the degree of quality and quantity of idea, man will expand and enhance his life's value to the cosmos and subsequently to himself.

> By means of self-adopted ideas, man enobles and dignifies his existence and speeds the greater fulfillments motivating the primal causes of being, portrayed by the radiating consciousness expanding from the idea's fulfillment in the upward-moving rays of praise and adoration.

The artist generally is a creator, a transformer. Art is man's way of fulfilling the saying, "Behold, I make all things new." Out of the raw materials of mind and matter, the artist with skill and imagination designs and constructs a novel creation, a work of art that embodies or symbolizes some significant human value in a satisfying sensuous pattern that never existed before. The function of artistic creations is to objectify, to enhance, to illuminate, and to perpetuate human values.

Many human themes arrive in the artist in visualizations for which there are no words. In *Assault* (color plate 6), for example, Louise Janin dramati-

17. MYKOLAS KONSTANTAS ČIURLIONIS. *Sonata of the Sun, Andante.*
Tempera on canvas. 63½ cm. x 58½ cm. 1907. Courtesy of the
Čiurlionis Art Museum, Kaunas, Lithuanian Soviet Socialist Republic.

18. MYKOLAS KONSTANTAS ČIURLIONIS. *Rex.* Tempera on canvas. 59″ x 52½″.
1909. Courtesy of the Čiurlionis Art Museum, Kaunas, Lithuanian Soviet
Socialist Republic.

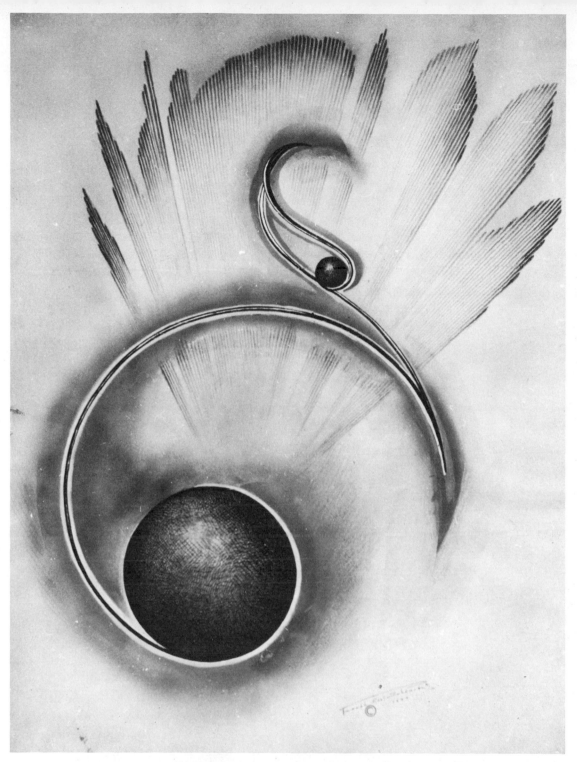

19. JOSEPH EARL SCHRACK. *Birth of an Idea*. Watercolor. 22″ x 24″. 1940.

For every manifestation there is a primary cause. Each idea, issuing from the universal storehouse, is destined to find fulfillment in its credited time and place. Man conceives satisfaction as an immediate demonstration. Not so with the timeless qualities of superdimensional cosmic forces. In this larger aspect of multidimensional timing, the important factor is proper timing, bringing each element into fulfillment in its proper relation to every other seed-idea seeking fulfillment. When born according to proper timing, the results will be conclusive.

Joseph Earl Schrack

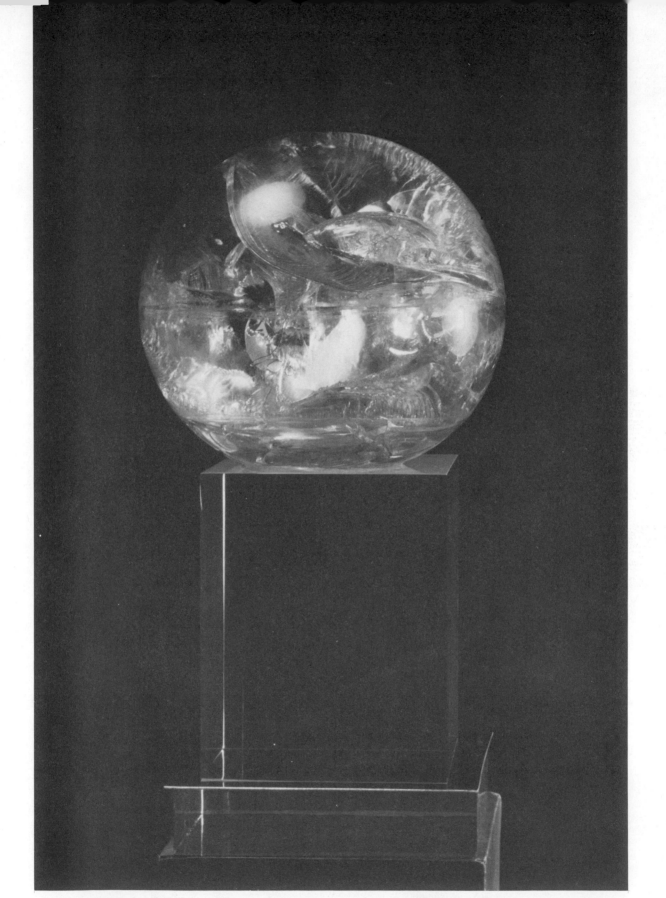

20. JEANNE MILES. *Polyester Sphere #2.* Cast polyester. 5″ diameter. 1963.
Courtesy of the Newark Museum of Art.

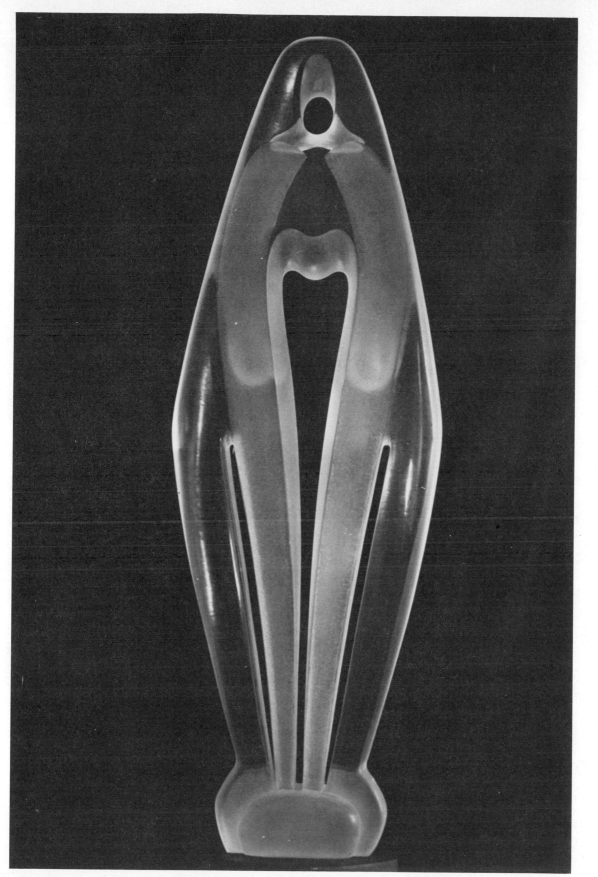

21. ALEXANDER ARCHIPENKO. *Exaltation.* Electrically lighted transparent
plastic. 3′ high. 1947.

cally portrays every man's daily battle between good and evil. This painting speaks clearly for itself, in distilled visual language that one can feel directly. It is a glowing, soaring creation. Its power carries the viewer out and up into a symbolic and spiritual dimension where dialogue, decision, and action take place.

In *Isabel of Castille* (color plate 2), Janin creates of dogma, the central mystic almond, extending and supporting on its axis a reverberating and soaring structure, perhaps a suggestion of womanly nature.

The four panels of Krishnalal Bhatt's *Transformation* (color plate 4) reveal succeeding stages of the transforming spiritual process. The first panel indicates a tree aspiring to light, the second panel the result of aspiration as fruits of light. The third panel represents the tree—or human awareness—becoming illumined by stronger aspiration. And in the fourth panel, the tree itself is transformed into light.

In *The Golden Purusha* (color plate 3), Bhatt declares that "purusha" means conscious being. The self (purusha) is that aspect of the supreme absolute that is intimately felt as at once individual, cosmic, and transcendent of the universe. This conscious spirit, while retaining its impersonality and eternity, its universality, puts on at the same time a more personal aspect. In this way, the self, both as cause and as individual, comes to embrace the whole world and all other beings in a sort of conscious extension of itself.

This conscious extension often perceives greater parts of the universe, as in Gerardo Dottori's *Flight over the Ocean* (color plate 1), where the embracing consciousness skims out over the sea and into space; or in *Fragment of a World* (color plate 5), where various general aspects of the physical universe are in the process of being recombined.

The *Divine Omnipotence* by Erwin Dom Osen (color plate 7) calls forth the countless fiery suns that are manifest in the everlasting love of creation, while in *A Planet to Die Away* (color plate 7), the vast energies of creation, here in the revealing power of color, begin to surge once again into the immaterial away from the personality of matter into the infinite.

Aesthetic values include qualities of feeling, emotion, and of transcending interest. Art becomes therefore the creation of forms symbolic of these human conditions.

When I think about life, I think of it as a room with two mysterious doors, one leading in and one opening out. To us who have entered and for a time occupy the room, a sustenance is siphoned back from without; and that sustenance is the purity and elegance of spiritual beauty.

Jeanne Miles

38

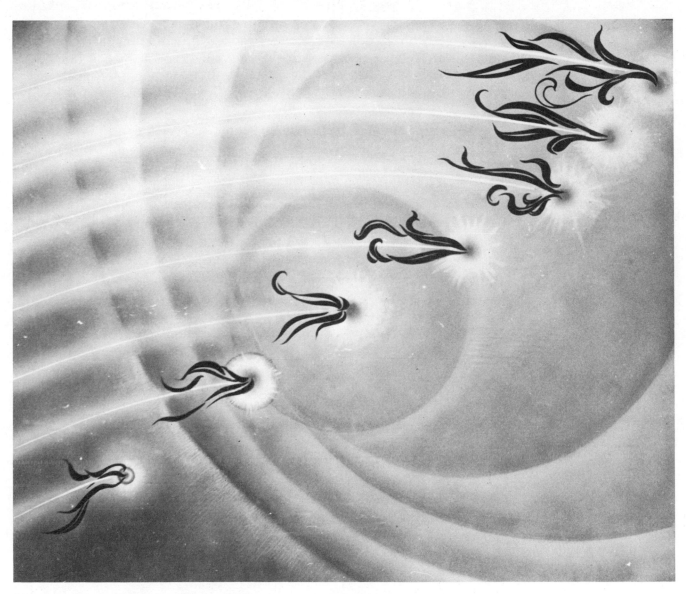

22. JOSEPH EARL SCHRACK. *Germs of Inspiration.* Watercolor. 22" x 24". 1940.

Here are shown advancing developments of inspiration's creative idea. In each successive stage, the germinal flair with its attendant flame grows increasingly stronger, leaving behind the lengthening trail of its progressive course, which, in turn, expands with time and distance covered.

Joseph Earl Schrack

Alert responses to artistic creations enlarge our emotional life, our transcendental interests, in at least three ways. First, we may experience a multitude of new feelings and values that we did not know before. Second, artistic works may become symbols for a multitude of human feelings for which no adequate words exist. Many artists have expressed the fact that language is notoriously poor when we try to analyze and categorize the inner worlds.

And third, works of art perpetuate emotions. Works of art that we know, or perhaps have created ourselves, often provide opportunities for renewing waning emotions and interests. Many noble feelings are lost because there is no word or artistic work to preserve them from sinking into the oblivion of the unconscious.

The fine arts become the enduring vehicles of the values that an individual or a civilization cherishes. As Christopher Caudwell has indicated, "It is through art alone that Greece invites our love" (8). Thus one who persists in sensitive responses to great works of art gradually becomes imbued with the sentiments that mark a civilized man. Sculptor Ponomarew (illus. 80–82) believes that "the miracle of art is achieved when blocks of stone speak to us, stir emotion, and remain for centuries to accomplish their role."

3

DYNAMISM OF THE WORLD

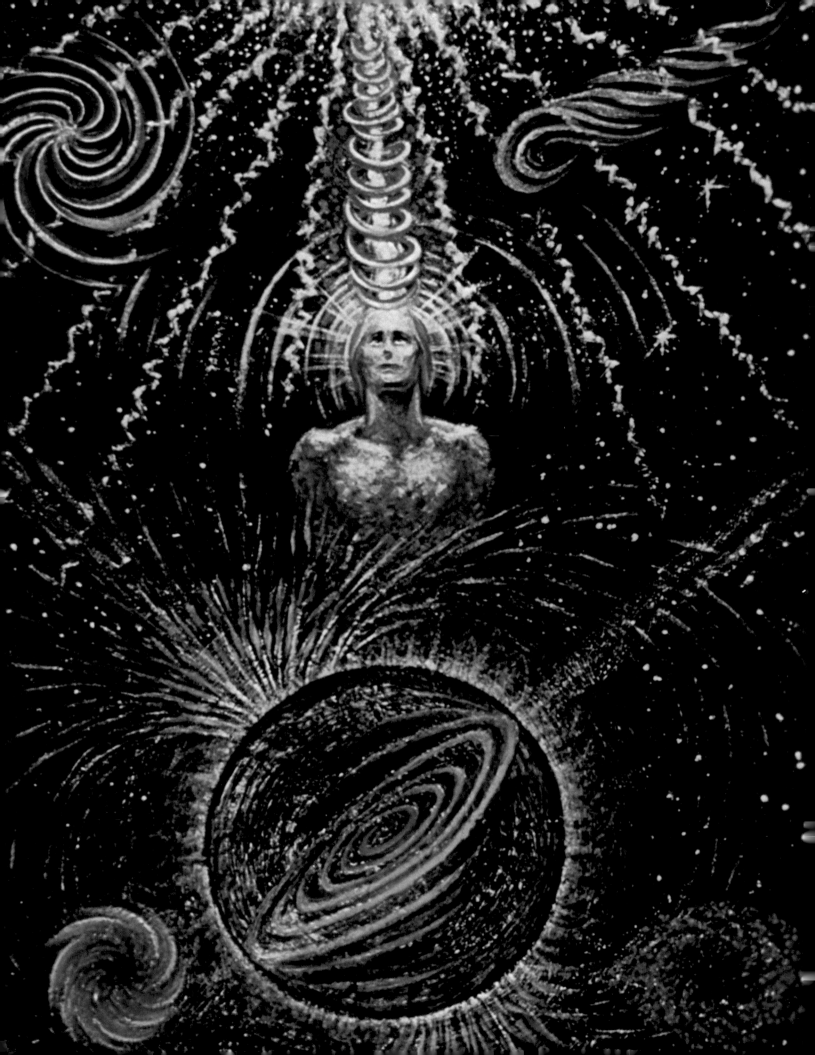

10. COLUMBA KREBS.
The Vortices of Outer Space
(left). Watercolor. 20″ x 24″.
1950.

11. HUBERT STOWITTS.
Antahkarana. Tempera on
canvas. 24″ x 36″. 1947.

12. MAULSBY KIMBALL. *Trial by Fire.* Watercolor. 20″ x 30″. 1957.

15. RUTH HARWOOD. *Ascendent Flame*. India ink and tinted drawing.
4″ x 6″. 1950.

16. FAITH VILAS. *Necromancy and Nativity*. Watercolor. 20″ x 24″. 1947.

17. STAN BAELE. *Death*. Oil on canvas. 40″ x 48″. 1948.

18. COLUMBA KREBS. *The Human Realm* (top). Oil on canvas. 20″ x 24″. 1956.
The Universal Kingdom (bottom). Oil on canvas. 20″ x 24″. 1956.

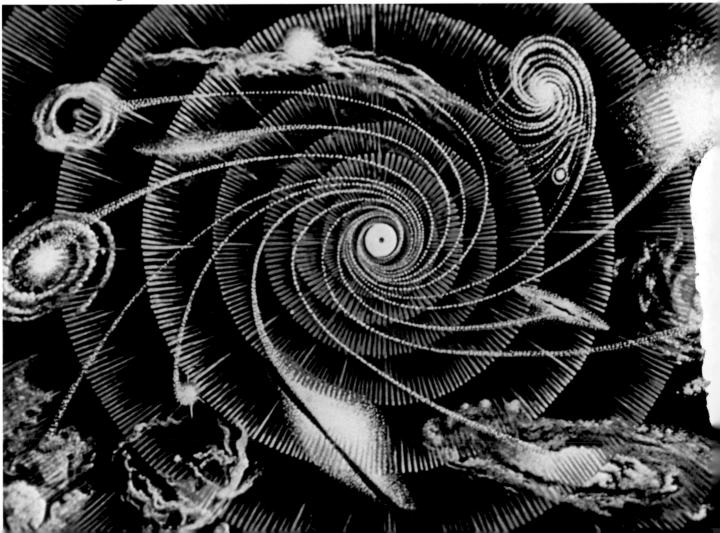

Reality or cosmos is meant to include everything that is, everything that acts or that occurs. It is, in a word, total existence. All men demand reality. Cosmic artists, therefore, are brothers to metaphysicians and religionists, who also seek to know and to communicate, to enjoy and to live by the fundamental characteristics of reality.

Recognizing reality in consciousness includes the use of *perception*, which is recognition by sight, seeing the obvious, the physical; the use of *thinking*, recognition by mental exploration and analysis or by logic; and recognition by *intuition*, the psychic, the immaterial beyond physical perceptions. Intuition is pure, psychic, untaught, noninferential knowledge. It is often spoken of as a sixth sense or as one's ability to feel or to apperceive situations. It is consistently expressed in the works of interpretive musicians and artists, their expressions being aesthetic, social, introspective, and sometimes mystic. Intuition often yields a concrete living truth that mental reflection or sight alone does not effect.

Cosmic art both reveals and expands realities. It is the inevitable consequence of the beauty of nature and the basic desire of man. Many aestheticians and artists have noted this basic premise in art.

I am in love with the beautiful in all its manifestations, from the life of man to that of nature and the infinite. I behold the sky; I think of the infinite. All my art is a metaphysical endeavor to overcome visible realities. I search for synthesis and strive to realize a pictorial poem, with as much lyrical content as possible. A painter is a poet who paints poems.

Gerardo Dottori

Art is one of the most profound means at man's disposal for comprehending reality. (9)

Charles Biederman

I believe that most painters today are not leaving reality but are going deeper into it. They are concerned with the form of things beyond the visual, the meaning behind the facts. (10)

Margo Hoff

Driven by a tremendous urge to pursue the real until it is captured, the artist searches endlessly to bring within the confines of time and space the infinity with which he feels himself to be a part. The search for the real will drive him until the day of his death. (11)

Lynda McNeur

Art deals with reality. Every artist of genius becomes a transformer of the meaning of the world. (12)

André Malraux

Two fundamental facts emerge that are important for grasping the cosmic significance of art. First, reality is not fixed but is infinitely unfinished. New entities are ever appearing; new machines, cities, landscapes, and artistic works; new personalities, emotions, societies, events, and philosophies. The idea of the fixity of things is a fallacy.

Second, reality is not something automatically given to us, like a photographic impression. Rather it is a conception, an attitude of mind, a philosophy, an ideology, or a religion, which one must construct, work for, attain, remake, and live; and one's construction, which is reality, is always subject to change, to error, and to correction. One's view of reality, one's viewpoints, must be ever renewed as fresh data or insights assail us.

In considering the aesthetic theories behind cubism, for example, Christopher Gray indicates the quality desirable in one's viewpoints.

True reality is something highly personal and subjective that depends at least as much on the idea and attitudes of the observer as it does on sense stimuli from the external world. Inevitably, true reality must change with the change of ideas and attitudes. It can no longer remain fixed and permanent, but must be dynamic [and] . . . highly pragmatic in nature (13).

The artist, then, is not a reporter or a photographer but a creator of new individualities. He imparts a wondrous new shape and emotional quality to the original raw material with which he starts. An artistic work is a piece of reality transformed by human imagination and skill and informed and embued with human emotion and purpose. Many artists have given testimony of their awareness of the necessity of this transformation.

44

I do not seek to paint pictures. My wish is to create reality for myself and perhaps the spectator. (14)

Leo Manso

Artistic creation is the metamorphosis of the external physical aspects of a thing into a self-sustaining spiritual reality. (15)

Hans Hoffman

Art is creation. The artist finds the aesthetic world only by constructing instruments and symbols. . . . He bends reality in the direction of the magic dream; then gives to the dream the compelling power and savor of reality. (16)

Henri Delacroix

Any conscious and illuminating contact of the self with reality is called truth. If truth comes in different forms, it is because reality has various aspects or dimensions which the self may consciously seize or possess: the phenomenal (actual, perceptual, observable, concrete physical-organic); the selfic (intellectual, social, nonsensuous world of thought and the thinking man); and the cosmic (spiritual, psychic, intuitive, transcendent), this latter realm being the dynamic ground or source for action in the world.

The necessary sensuous basic qualities of the fine arts has brought mankind rich fresh knowledge of the concrete qualities and textures of perceptual, physical things. Through visual, auditory, and kinesthetic senses, the typical arts of painting, music, and dance have abundantly added to man's enjoyment and understanding of perceptible things. Representational art rightly continues to make known and to glorify the beauty of the physical universe.

During the last half-century, however, a historic revolution has been working a drastic change in Western plastic art. This metamorphosis consists of a radical shift in the controlling motive of artistic creation, a shift from the intent to represent natural objects to the will to express human emotions, ideas, or intuitive and psychic visions. The center of artistic motivation has passed generally from creating landscapes to exploring "inscapes," from physical sense perception to spiritual apperception. In a general sense, the reality of the mind and the psyche has been substituted for the former absolute reality of the eye.

The animating source of all arts and artisms is the living human being, the individual creative self. Fundamentally, the self is a conscious or experiencing agent that acts and perceives through the physical senses of the body. It also feels, strives, remembers, and learns. But it can also think and imagine, using symbols, plans, choices, and constructions. It can be introspective, intuitive, and psychic, and it can transcend the immediate realms of the physical and ordinary thought. Above all, it develops various value structures or dimensions that become more or less unified into a

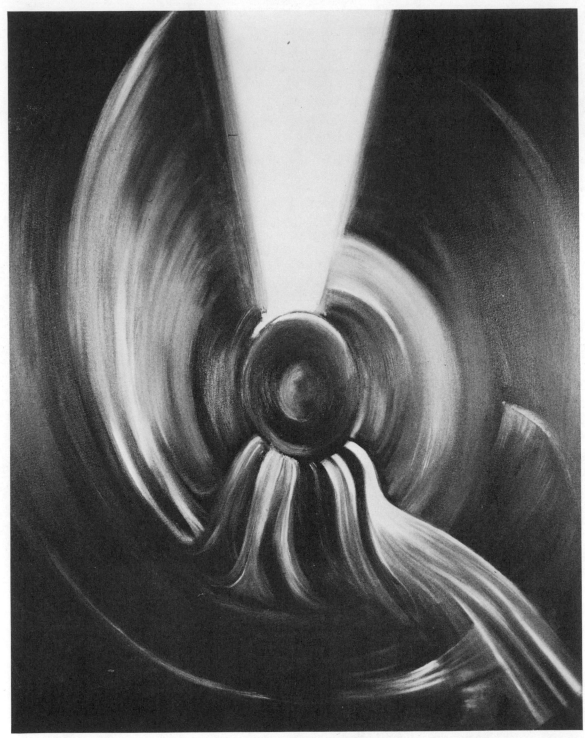

24. MICHAEL OROGO. *And There Was Light.* Oil on canvas. 28″ x 36″. 1942.

I pray—I conceive—I feel—I paint. I do not limit myself to my knowledge of the obvious.

Michael Orogo

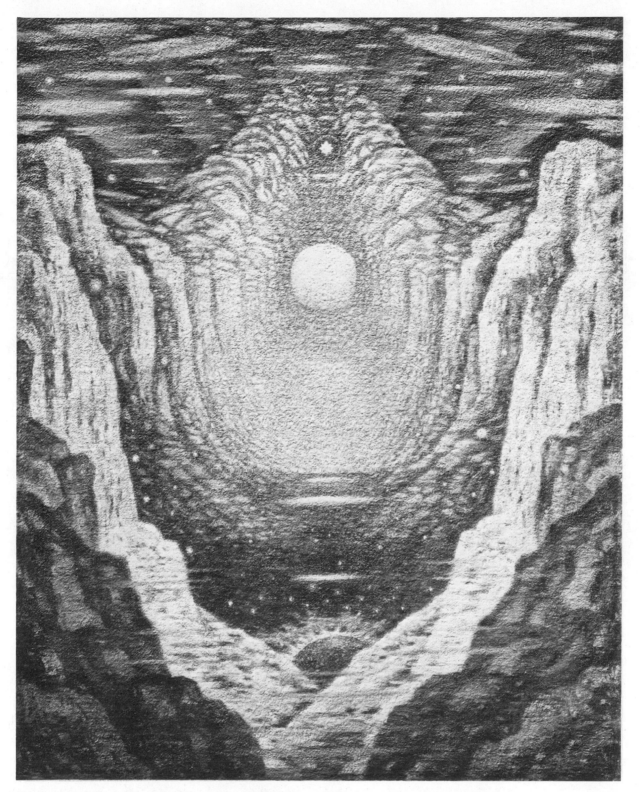

25. GEORGE GRAHAM. *The Morning of Creation*. Oil on canvas. 36″ x 38″.
1942–1944 Courtesy of Mr. Hugh Griffiths.

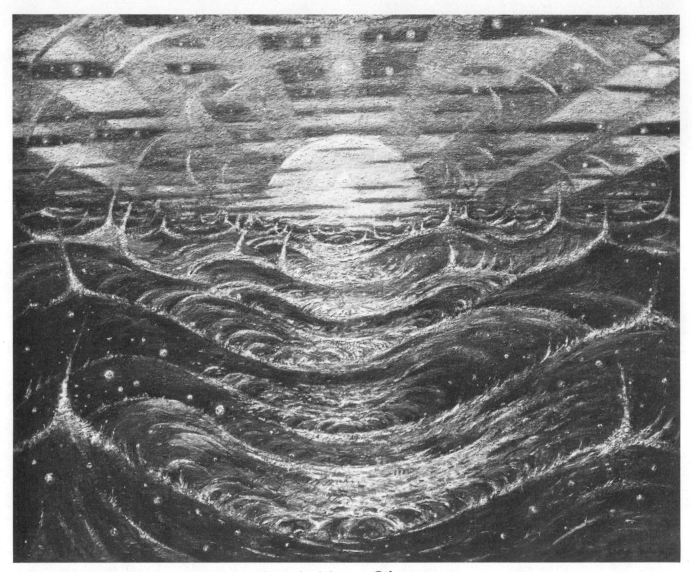

26. GEORGE GRAHAM. *And Spirit Moved on the Waters.* Oil on canvas.
24″ x 20″. 1940. Courtesy of Mr. Hugh Griffiths.

Art-and-mind is such a very complex thing, and where an artist thinks off the beaten track there will be few to follow his line of thought. The comfort of the well-worn path is great, but it leads to decline and a muddy, flattened way. It is best for the artist to forget his finished work and live for the future—what he hopes to do. When my time comes to go, I hope there will still be on the easel some unfinished vision, something beyond the everyday life, something that links me with the next great adventure.

George Graham

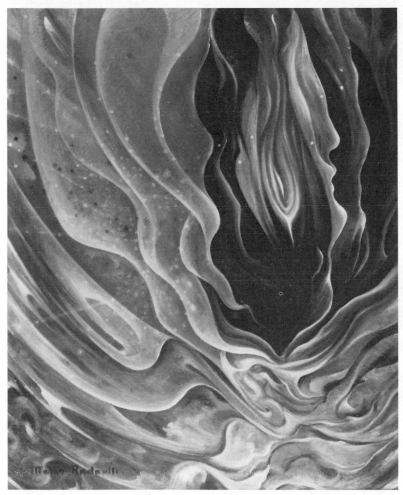

The principle which gives life dwells in us, and without us, and is undying, and eternally beneficent; it is not heard, or seen, or smelt but is perceived by the man who desires perception.

Mario Radaelli

27. MARIO RADAELLI. *The Flower.* Oil on canvas. 81 cm. x 65 cm. 1949. Courtesy of Miss Florence Allen-Volk.

28. MARIO RADAELLI. *The Gods.* Oil on canvas. 23⅔" x 29½". 1949.

The soul of man is immortal, and its future is the future of a thing whose growth and splendor have no limit. Religions are only subdivisions of this eternal truth.

Mario Radaelli

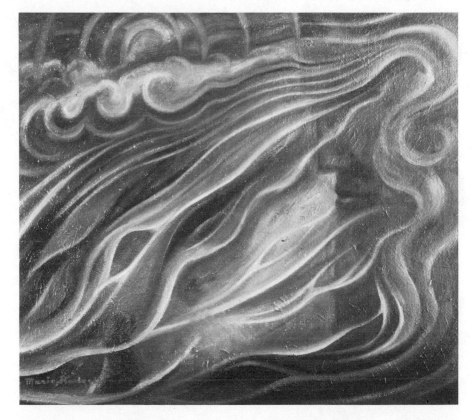

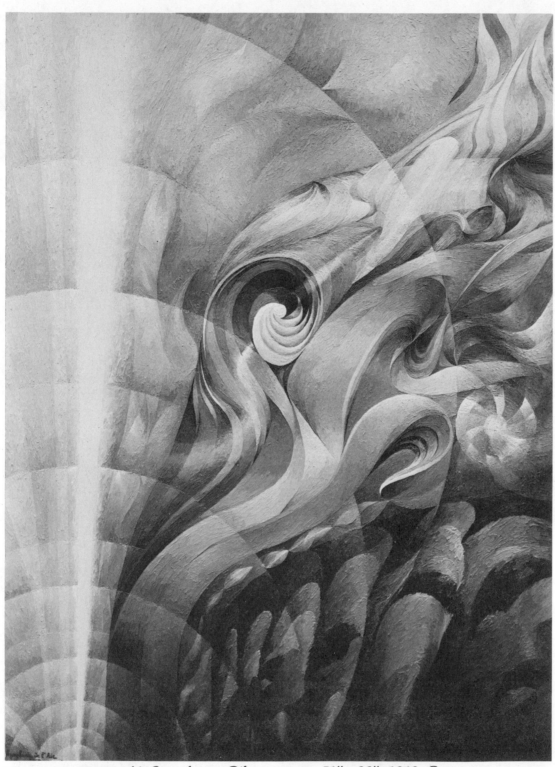

29. HENRY VALENSI. *Air Symphony*. Oil on canvas. 51″ x 38″. 1948. Courtesy of H. C. Bechtler.

I paint only when my mind has a message to express, when some idea or emotion has awakened it.

Henry Valensi

unique personality or selfhood. In many people this is a continuing achievement.

Yet the potentialities of the self remain mysterious. They have their marvelous hints; what man has done, men do—and, surely, more. What effects, what traces of the ages lie dormant in one's self? The implicit memories of this life, hints of other dimensions and worlds. The artistic genius unfolds these human endowments with peculiar intensity and richness. The continuing need, the eternal problem of the artist—indeed, of everyone—is to build a larger, finer self, to become a more effective, generous, and joyous person. As a result of this continuing need, and because of the shift inward from solely a physical type of art to the inner nature of man, the contemporary artist—perhaps the true modern artist—is concerned with what is going on in the depths of the soul.

This shift inward is characterized cogently by Mario Radaelli (illus. 27, 28) who states:

> The work of the painter is not a mere reproduction of the superficial appearance of things, but the emotional-intuitive discovery of their intimate truth; their character, reason for being, expression, life. The artist achieves this discovery by identifying himself with the true interior life of persons and things aided by his fine feelings and sensitivity.

> Then in the orchestration of his canvas, his work of art, he creates a new world that makes the veiled essentials or subconscient truth become transparent and clear. He organizes such color-form-imagery that the abstract emotional truth bursts forth as a revelation with all its strength and mysterious beauty. Art teaches us to realize truth in the light of feeling as science is the way to discovering truth in the light of the mind, or thought.

> The preceding approach constitutes subjective and symbolic painting. It is an orientation, not a school. It is a new horizon that holds unlimited possibilities for contacting the profound kingdom of the spirit. In this orientation each creator must trace his own course of development and rely confidently upon his divine originality.

In describing his painting, *The Gods* (illus. 28), Radaelli indicates that the manlike face at the right behind the racing vapors refers to one of the many extracosmic gods which our ignorant ancestors made in their own likeness and passed on as sacred things through generations of tradition. It is an elementary, pitiless creature to which the pain and sorrow of humanity vainly appealed century after century.

Flowing from this stern being, however, we discern intimations of the power of the true being, the immanent and universal, the soul of everything, which is found in man only within himself, although it is manifest in the impassive, eternal, natural laws that surround us.

In Michael Orogo's *And There Was Light* (illus. 24), the egg of being bursts into vibrant light and whirling energy. George Graham was always concerned with the play between darkness and light, quiet stillness and unbounded activity—the breath of life. He said:

> Whenever I attempt verse, I get no further than four lines and have to give it up. But in paint I can go on until the idea is expressed. Poetry, as you know, is the foundation of all art, and I believe many people *live* poetry who do not write or paint it.

In his *Morning of Creation* (illus. 25), Graham suggests the tranquility and satisfaction of creation, before movement began in it, before the egg of being and motion stirs into action. In *And Spirit Moved on the Waters* (illus. 26), conscious, cogent motion has stirred the universe.

Air Symphony by Henri Valensi (illus. 29) is an example of musicalism, a style of abstract art that incorporates into a painting the dynamic, rhythmic, and evocative qualities of music that we know are also inherent in our cosmos. Valensi indicates that *Air Symphony*, the stirring of motion in the universe, embraces three movements; that is to say, three ideas. At the left is the air which gives life. Radiating lines ascend from the base, breathe freely, and expand themselves. In the center, the air which gives force sustains the wings and turns the windmills and turbines. At the lower right is the air which gives death, by tempests and hurricanes which bend and break. In this painting, dynamic rhythm becomes the basic ordering principle in the artistic creation.

Another view of the universe is given by Victor de Wilde, who, in his painting *In the House of the Lord Forever* (illus. 30), speaks out of life on, above, and beneath the "crust" of this earth, the constant action of energy everywhere at all times. In *The Winged Eye* (illus. 31), Edmond Van Dooren symbolizes the human longings and nostalgia towards eternity and the endless spaces, the modern spirit of man who tries to embrace the whole universe and its forces in his mind. It symbolizes a kind of spiritual assault against all material obstacles that hinder the free flight of the human soul. It realizes the basic power of striving into superreal and ideal values, the human spirit discovering itself as an equal element of the eternal universe and its metaphysical values.

The feeling of *Guardian of the Planet* (illus. 32) by Philip Perkins is one of a rampart set in a floating infinity in which there exists that guardian that watches and guards. To Perkins this was the perfect metaphor for a divine quality of mind that operates in all planes.

The rhythmic, sensuous qualities of *Cosmic Mother* (illus. 34) by Marina Nuñez del Prado invite the observer to explore and enjoy tactile values. Yet the empty space, the hollow, invites the mind to drop from the strong sensuous delights into the nonmaterial world of thought and beyond into the rhythmic surge of the cosmic universe.

In her large, scintillating mural, etched and painted on stainless steel, entitled *Man's Search for Reality* (illus. 33), Buell Mullen visually brings alive the feeling that down the ages filter particles of life, of light or vitality, which

come into being as a race of scientists. The foremost holds the crystal ball of intellect. Their hours on earth are marked. Flashes pierce the fog of ignorance in man's search for reality.

In *Dynamism of the World* (illus. 23) Gerardo Dottori gives us a view of the spiral beam of light, a vast architectonic form that lifts one to the grandeur of the universe that so infinitely surpasses the wonders of the mind of man so far, and that gives a hint of the interaction of cosmic forces on this earth. To Dottori, the artist is always a mystic or psychic whenever he finds himself exercising his function. He seeks to stylize, spiritualize, and deify nature.

Artist Victor Mideros states that art is an ascension in search of eternal types of things. A painting, written with its lights and shadows, forms and colors, animated by the breath of the artist's soul, becomes a visual messenger that goes forth to seek a dialogue with another human soul. In his brooding, mysterious painting, *Cosmic Consciousness* (illus. 36), Mideros renders his vision of cosmic glory reflecting and shining upon the organized plateau of a cogent, perceiving, well-rounded mind.

Faith Vilas was not only an artist but a very sensitive psychic with a wide and judicious knowledge of inward, parasensory awarenesses. Her paintings display the lightness of air and the transparency of light. They are abstractions of major universal themes, completely fluid, eerie in form, texture and emotional impact. In *The Morning Stars Sang Together* (illus. 35), one views the gentle but powerful fluxes of a universe in harmony.

Vilas was also a visionary for the future of aesthetics. As she wrote in correspondence:

> In an age awakening to atomic forces and nuclear energy, the creative artist, that most delicately sensitized of human beings who from earliest time has been seer and prophet, must not be content to paint old subject matter even if he tries to give it a new flavor by twist and distortion. He must capture for his work the future, the unknown; he must project his vision into those unexplored dimensions just beginning to lift above the horizon.

> The art of any tomorrow must be largely a matter of evolution and cannot be arrived at by superimposition of the bizarre and startling. Distortion and the return to childish naïveté that had their hour in the course of growth have no more place in a more mature art than creeping on all fours becomes a man who can stand on his own two feet.

> Any art of the future must instinctively well up out of a very deep and sincere emotion, passing through many phases of established tradition, till it becomes manifest in a spontaneous flow that arrests because of its sincerity, vitality, and utterly unique approach. The artist must understand and savor the best of yesterday's masterpieces; he must become familiar with the rules governing them, practicing them if need be, before he can cast them aside to start upon his new and untried course.

30. VICTOR DE WILDE. *In the House of the Lord Forever*. Oil on canvas.
30½" x 36". 1947.

It is my belief that there is no oblivion.

Victor de Wilde

31. EDMOND VAN DOOREN. *The Winged Eye*. Gouache. 50 cm. x 70 cm. 1955.

Art is not a simplification of the external world but an endeavor to make palpable the wonder in the very nature of things, even in the most humble. This marvel is the breath or emanation of that mysterious, omnipresent love of the unique supreme being that is the soul of all life. The real artist is always busy trying to express in sensuous symbols this supranatural harmony of man's highest aspirations. Thus the essence of art in its profound meaning is simultaneously religious and cosmic, for cosmic means linking man to universal purpose.

Edmond van Dooren

There is for me only an intuition, a sentiment more real than reality, but more intangible than a shadow. The old Chinese and the impressionists really sensed the movement of spirit in the forms and light of the earth; but now is the time to sense it in infinite cosmic space.

Philip Perkins

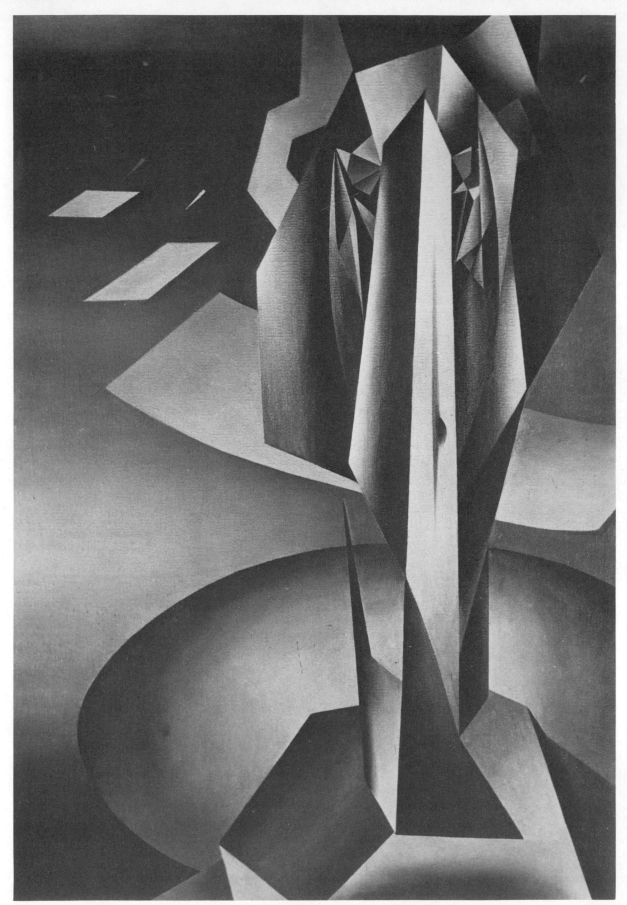

32. PHILIP PERKINS. *Guardian of the Planet*. Oil on canvas. 24" x 16". 1947.
Courtesy of Mr. G. E. Freeman.

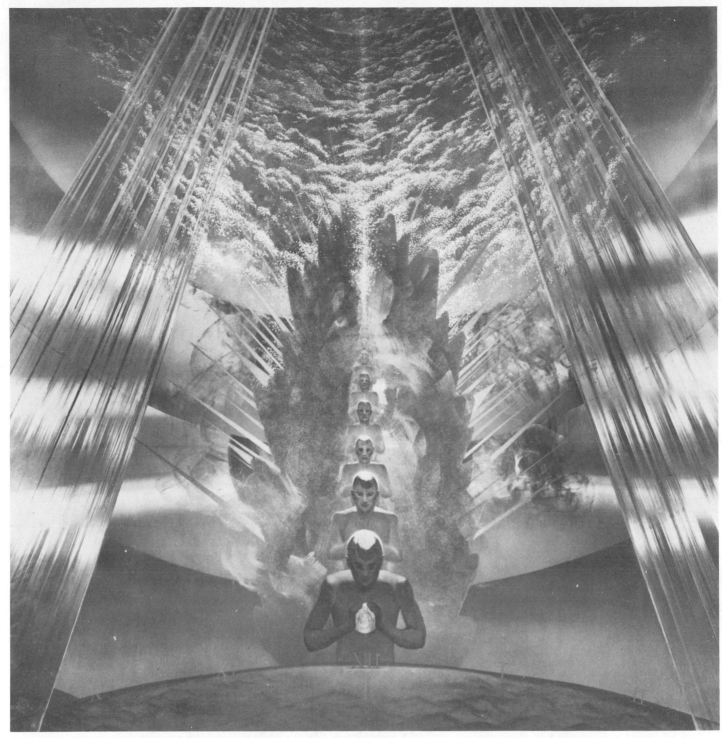

33. BUELL MULLEN. *Man's Search for Reality*. Epoxy paint on stainless steel.
10′ x 10′. 1948. Courtesy of IT&T.

Contact of man to man, mind to mind, is the principal function of life and growth. The inner vision, the capacity to see beyond what is to what might be, as a searchlight penetrating the world of ideas and abstract truth, is the basic reason and responsibility of art. To fulfill this responsibility the future artist must be dedicated to concentrated aspiration, working not as a solitary mind but as a collective associate, towards the goal of culture, a spiritual farsightedness, participant psychologically as well as technically of the age of spatial involvement.

Buell Mullen

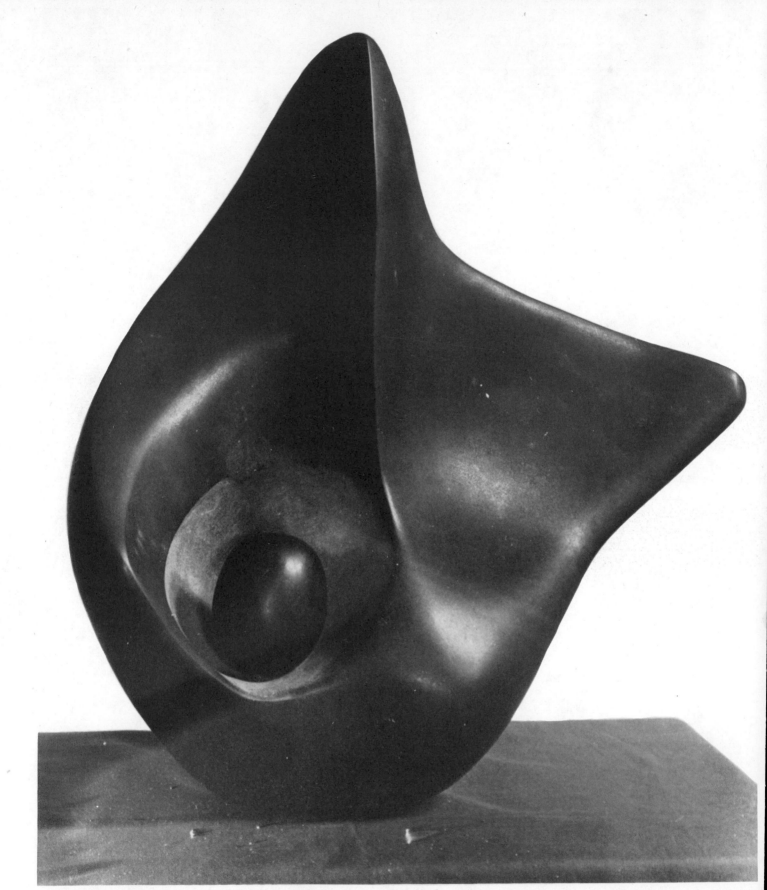

34. MARINA NUÑEZ DEL PRADO. *Cosmic Mother*. Basalt. 20″ high. 1961.

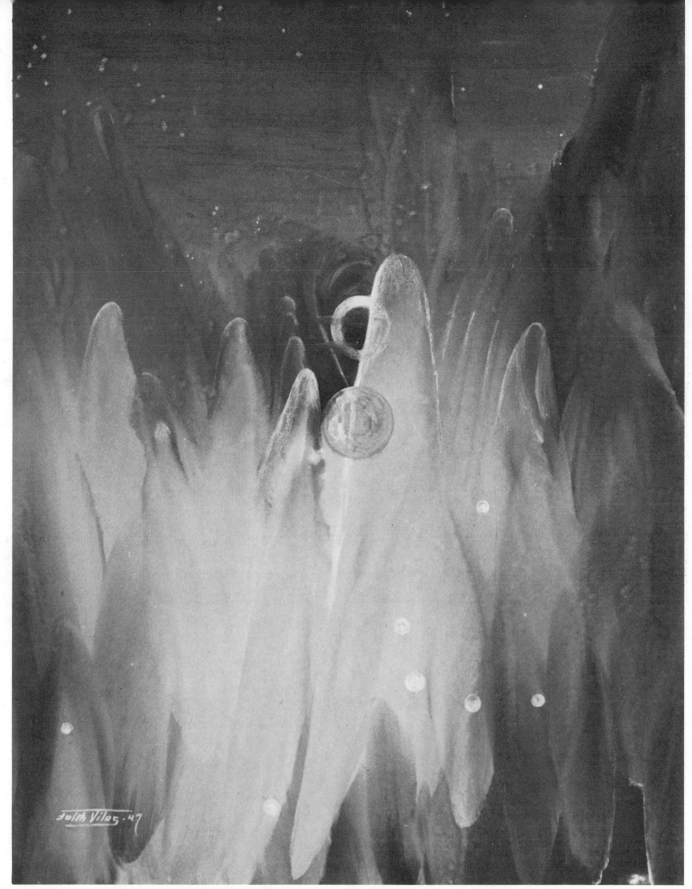

35. FAITH VILAS. *The Morning Stars Sang Together*. Watercolor. 16″ x 20″.
1946.

36. VICTOR MIDEROS. *Cosmic Consciousness.* Oil on canvas. 25″ x 40″. Circa 1950.

Art is an ascension in search of eternal types in things. A painting with its lights and shadows, form and colors, animated by the breath of the artist's soul, becomes a word messenger that goes forth to seek a dialogue with another human soul.

Victor Mideros

Let him first achieve awareness, and then let him find his subject matter by cultivating an appreciation for that which lies within himself as well as out and beyond the obvious horizon.

Beauty—a compact name for the totality of aesthetic wonderment and delight—is cosmic in genesis and universal in allure. It is rooted in perception of reality. It requires order. And order, infinitesimal, sublime, or grandiose, permeates the patterns and processes of the universe. Hundreds of scientific laws guarantee this grand theorem, and it is confirmed by all the exquisite wonders of concrete nature: molecules, crystals, plants, flowers, seashells, the marvels of the human body and psyche, and the celestial constellations and revelations. In short, the atomic, mineral, and biologic realms are constructed artistically, aesthetically, and usually beautifully. The inexhaustible variety of form demonstrates the unending originality of nature and the generosity of its inherent impulses to beauty.

When the vision of the artist shifts from the perceptible to the cosmic, he contacts the inner worlds, the realms of spiritual activity, of psychic perception, and the beautiful universes of abstract truths. This transcendence is hardly anywhere else found so cogently stated as in a poem written for the Pipers by Faith Vilas:

> If we painted what we saw,
> Wrote what we heard,
> How dull the canvas,
> Arid the word.
>
> Brilliant is the color
> Our brushes borrow
> That plunge into yesterday,
> Delineate tomorrow!
>
> Words that carry echoes
> From beyond the fleshly wall
> March in eonic cadence,
> Light-tipped and tall.
>
> We live in a valley
> Sunset behind one hill
> Sunrise beyond the other,
> Mysterious . . . still.
>
> Let who paints or versifies
> Learn in his youth—
> Farther out than sight or sound
> Lies truth.

4

THE UNIVERSE AND WE

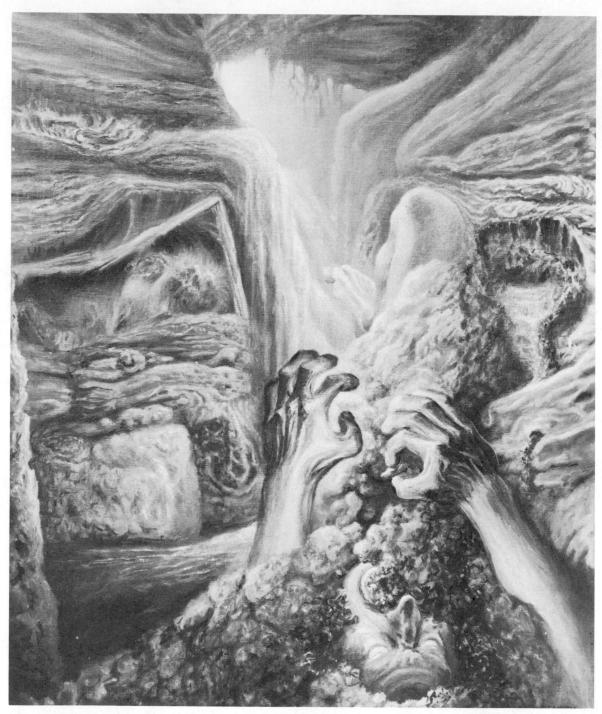

37. TERRENCE DUREN. *Man Inherits the Earth*. Oil on canvas. 28" x 32". 1948.

Into the dark the life proceeds.

Terrence Duren

The birth pangs of emerging new ideas of man, of the individual, of nations, of world concepts, of big and small wars, of swift change, of spectacular new means of communication, all have created in our time an intense worldwide awareness of the vastness and variety of human suffering.

There seems to be, unfortunately perhaps, an evil or a badness in opposition to every kind of good or positive value, as sickness and health, poverty and wealth, vice and virtue, boredom and adventure, war and peace. Escapes from evil include some of the most intense forms of human joy while the mastery or conquering of an evil develops human values and helps build the good life.

Artists who seek to express the realities of contemporary man, especially cosmic artists, must have a workable conception of this baffling problem of suffering. Many artists portray a cryptic, vehement, and often tragic image of man, seeking images perhaps powerful and awesome, at times eroded and isolated, often anomalous and uneven, images of ecstacy and pity. Many of these art works combine ambiguities of tradition and the resonating irrational of common experience.

Among the three thousand artists whose works were reviewed for this book, in one form or another the most common theme during the past fifty years has been the Crucifixion. The luminous cosmic setting of Sylvia Leone Mahler's unique creation (illus. 64) provides hints as to why the Crucifixion has been such an important and captivating theme for modern artists. This drawing suggests that, although suffering is inevitable to man, even the climactic experience of death may be redeemed in some way in the future.

38. MORRIS GRAVES. *The Individual State of the World*. Gouache.
30¼″ x 24¾″. 1947. Courtesy of the Museum of Modern Art,
A. Conger Goodyear Fund.

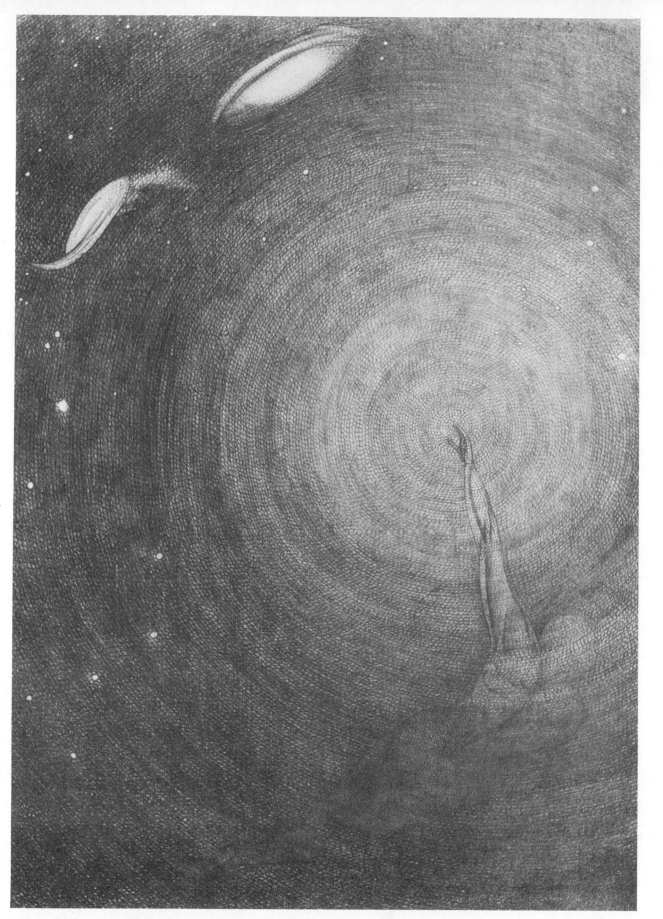

39. PHILIP MOORE. *Groping*. Pencil drawing. 21″ x 14½″. 1947.

Other common themes were those of individual suffering, social forces, death, and visions of hell. One of the most frightening modern paintings of hell is *The End of Humanity* (illus. 60) by Henri Frugès. The artist commands and holds attention by his fascinating images of evil persons, which he has organized with rhythmic vitality. He compels us to see and to feel the law of karma: these persons have become the images that correspond to their deepest desires in life.

Another work, the large mural *Metamorphosis 1942* (illus. 61) by Leo Katz, goes beyond the narcistic limitations of modern surrealism and contains a universal message from the subconscious. The pathos to be engendered by man's collision course with the onset of the futureless mechanical age was prophetically captured by Katz in 1942. At that time, a time when growth and prosperity were anticipated in general, the artist foretold the apathy that was to come as a result of human imagination becoming encaptured by mechanical concepts. Pegasus, the mythological flying horse of creative imagination, stands with wings clipped while his mechanical successor, the shark-faced plane, dominates the air. Around stands man encased in rock and steel, his feet becoming automobiles going in opposite directions with no place to go. On the ground, a second flying mechanical force looks with stupidity at its mythological ancestor, Pegasus defeated.

Many of the artists interviewed opined that evil was a departure away from good—and that therefore good can be reclaimed or discovered ultimately. The probability that every kind of evil lies just below a corresponding good provides a clue to the significance of pain to man—the meaning of evil is what it can yield in future good. According to the eminent Harry Emerson Fosdick:

> Everything worthwhile in life also comes from the same four factors whence its tragedies spring: namely, the law-abidingness of the universe; the evolutionary nature of the world; the power of moral choice; and the intermeshed relationships of human life (17).

Every evil seems to contain a potency and a promise that the wise, free, and aware man may transform into good, here or hereafter. Man has freedom to choose.

Thus evil is never the last word; it is sometimes a needful and hopeful transition to good, in that if a man is able to become aware of evil as evil, his awareness of it may encourage him to seek the better life away and upwards from it. The man of fortitude keeps his courage, his faith, and his hope. He avoids despair by the conviction that every experience of suffering may become the condition for a good not otherwise obtainable. The man of strength and cosmic awareness seizes evil and converts it into positive goals by eliminating the negative, often degrading characteristics. Cosmically, pain and suffering are often plows that cultivate the neglected earth of consciousness.

An artist's interpretation of human suffering may accomplish two benefits: he enlarges our grasp of metaphysical truth by giving focus and vivid-

One must be in love with eternity, so that one's works are at least a shadow of it. Immortality lies imprisoned within us. We must release it to the light. It is written that the Word was from the beginning—but it is not revealed whether the Word was first spoken or carved.

Ivan Meštrović

A sense of religion or religiousness is a monumental stairway up which man must climb toward self-realization. Struggle plays an important integrating role in the drama of man's existence on earth. To acquire wisdom, man must understand the source of suffering.

Henri Frugès

It is the inner being that must grow in power to take over the sloppy, stumbling, inarticulate fancies of the ego. Into the mind and vitals, as also into the purely physical matter, a more luminous, stable, wide, higher consciousness must descend with its infinite range.

Joseph Heil

40. IVAN MEŠTROVIĆ. *Supplication*. Travertine stone. Over life-size. 1946.

I do not separate the spiritual from the physical, but I believe that the whole cosmos is an indivisible unit, animated by a single life-giving power, directed by one all embracing intelligence.

Ivan Meštrović

41. MARINA NUÑEZ DEL PRADO. *Carryin' Life's Burden.* Walnut. 22" high. 1943.

42. KENNETH CALLAHAN. *Man, Time, and the Machine.* Tempera. 14" x 18". 1953.

Man is locked in self-created pockets of self-interest, self-adulation, worship of machine, and war; locked in religious groups, in lust and love; in family, social, civic groups, in national identities. Locked in these pockets, man does not see the sun from which life energy comes; does not see the rocks, the worms, the trees, the planets, and stars; does not see the life-sources, mental, spiritual, and moral.

Kenneth Callahan

ness to some aspect or form of evil; and he relieves the stress or pain by various aesthetic devices appropriate to his kind of art, infusing it with a kind of beauty. Artists may transform suffering by the use of the dramatic, of psychic revelation and vision, by excellence of craft and workmanship, giving a sense of intensified life and universalized and detached sympathetic feeling. Thus the artist balances dread and design so that the resulting whole is neither brutal nor frightening but both aesthetically pleasing and metaphysically illuminating.

Many artists have given visual birth to the dreaded in life, but in forms that satisfy the longing in many viewers of the transcendental, the spaces of mind and spirit beyond the physical immediate. In creating, for example, *The Individual State of the World* (illus. 38), Morris Graves produced a symbol of the anxiety with which contemporary man, in his search for spiritual values, peers into his mysterious subconsciousness and sees an ominous future. This painting was a result of "an effervescence of experiences accumulated over a lingering period of forty years to manifest a groping toward something I felt and desired, but seemed not to be able to reach."

This groping toward "something" is also succinctly reflected in *Groping* (illus. 39) by Philip Moore—man groping in the dark seeking for the light. Overcome by frustration and despair, man gropes in a sea of obscurity. Yet, through the pulsing gloom, he struggles toward a constellation of light that he dimly discerns.

The pain of life is severely, but beautifully, captured in the marvelous sculptures entitled *Supplication* (illus. 40) by the monolithic Ivan Meštrović, and *Carryin' Life's Burdens* (illus. 41) by Marina Nuñez del Prado, this latter being symbolic of the physical burdens of most of mankind.

In *Man, Time, and the Machine* (illus. 42), Kenneth Callahan portrays a synthesis, a powerful portrait, of the confusion that results from the materialistic machine domination of civilization at the sacrifice of human values. Here, man's vision of the physical and the spiritual world is warped and dulled by the immensity of the machine as he struggles in vain with the mechanized monster he has created. He also fights against time, which he has allowed to become master.

The misfortunes of the machine age are echoed psychologically in *She Had Many Faces* (illus. 56) by Juanita Marbrook-Guccioni, a painting done in a deep mood of contemplating the impermanence and change of material grandeur. The figure with many masks symbolizes the constant change of thoughts, moods, and consciousness. The torn, dusty drapery indicates the eventual decay of material substance against the background of the sky and sea, which are eternal by comparison.

Yet, as Marbrook-Guccioni indicates, "the subject exists in the mind, not in reality," an attitude cogently reflected in *Fear* (illus. 49) by Alice Harold Murphy. Seeking release, a despairing soul, perhaps, is tossed into eternity, as portrayed in *Lo, Here Am I* (illus. 50) by Charles Sims; or perhaps this represents a prefigurement of another kind of release, the soul flying into space, drawn by a resistless power, while underneath are the everlasting arms of consciousness, or supreme spirit.

73

43. HENRI FRUGÈS. *War*. Egg tempera. 28″ x 22″. 1950.

44. BERNARD O. WAHL. *Gold*. Oil on canvas. 24″ x 30″. 1948.

45. WILLIAM WARD BEECHER. *Dead End.* Oil on canvas. 20″ x 30″. 1942.

Fanaticism and devotion to stage-managed causes have marked most of the troubles in our history. What is more dangerous than allowing these "inspired" emotions to take the place of reason?

William Ward Beecher

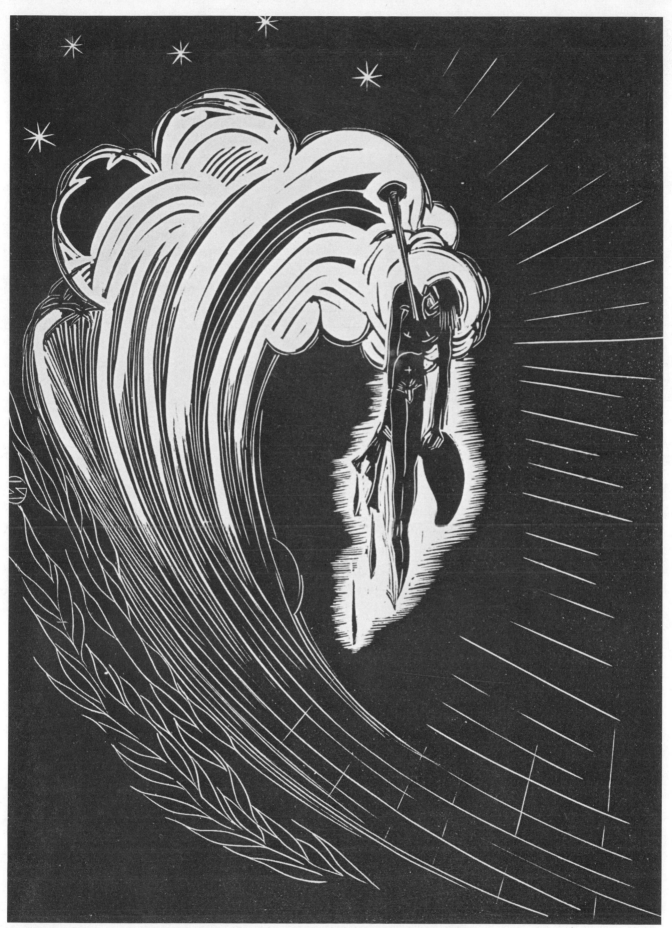

46. BLANDING SLOAN. *The Penalty of Genius.* Woodcut. 7″ x 10″. 1929.

The endless crusade of life itself is captured in *Being* (illus. 48) by Erwin Dom Osen, in a scene depicting the miserable circle of man's fears, sensuality, and despair.

Frederick Haucke, in his ominous *Phrenic Universe* (illus. 47), renders visible a vision of man's mind assailed by good and evil themselves. Here the artist is concerned with the mysteries of life and death. In this creation, he depicts the mind of man assailed by forces of both good and evil. A heaving, brainlike mass, which represents the mind of man, the world of living matter, occupies the center and indicates that man is open to assault from all directions. The artist says that the picture portrays the moral dichotomy in the universe; above are the shining hosts and the radiating waves of illuminated consciousness, and below, the dark abyss of evil with its skull emblem.

In *War* (illus. 43) by Henri Frugès, war is symbolic of personification of the struggle played as man attempts integrating roles in the drama of his existence, as in *Death* (illus. 52) by Paulina Peavy. Here, death, an open door, is the artist's conception of man's metamorphosis at life's end. The delicate tracery escaping from the ego represents the "crown of thorns" as the travail of birth ending in the opposite travail of death. The closed eye represents the subsequent return of the whole ego to its original single-eye or seed form; the original eye is called the nucleus, black being the symbol of the vast unknown.

In another vision of death, *In My End Is My Beginning* (illus. 55), John Farleigh gives us a picture that fascinates because it conveys in strong lines a universal experience; however poor the task one has just completed—perhaps even the earthly life itself—one now turns from its familiar haunts with a tinge of nostalgia, because one knows that in this perpetual miracle of linked wonders that we call living, the last word is in reality only the first of a new chain of events and purposes.

I have to integrate a great deal of experience to do a painting. The meaning of the painting is the charge of energy, the surge of interest that I put into it. My paintings have to do with man's place in the universe. Most of my themes are corollaries of birth and death. For every condition of our life there is an ideal pole to remind us of the fact that reversal or transformation is always possible. To me, a real picture is an axis around which the inner world of the soul is forced to revolve, creating new alignments of ideas and feelings, a larger, more inclusive view.

Frederick Haucke

47. FREDERICK HAUCKE. *Phrenic Universe*. Oil on canvas. 48″ x 36″. 1946.

48. ERWIN DOM OSEN. *Being*. Oil on canvas. 47″ x 47″. 1947.

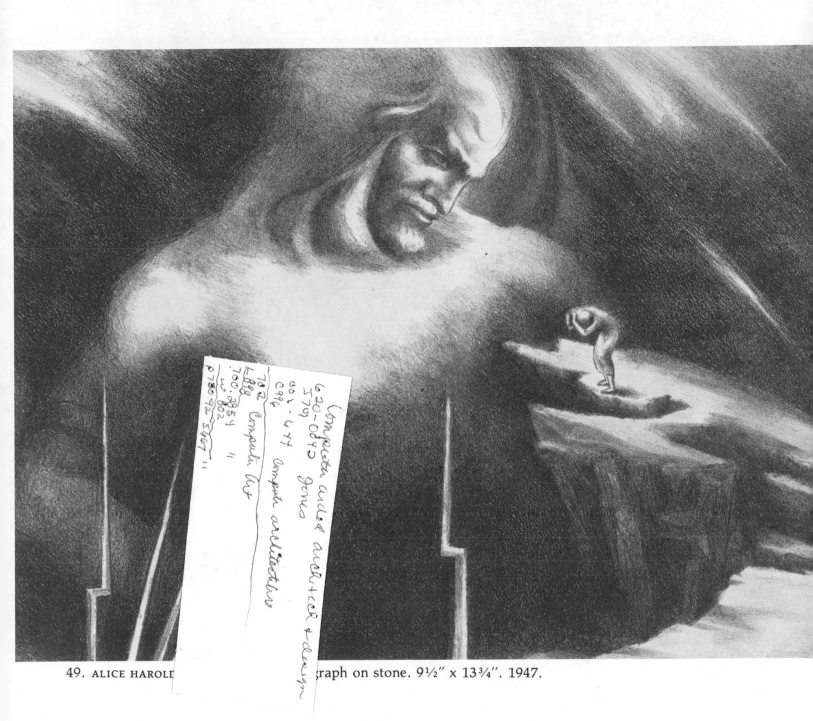

49. ALICE HAROLD [...]graph on stone. 9½" x 13¾". 1947.

The common denominator of art is rhythm, as it is of life, and it is when I am in tune with the rhythm of life that I succeed in a picture.

Alice Harold Murphy

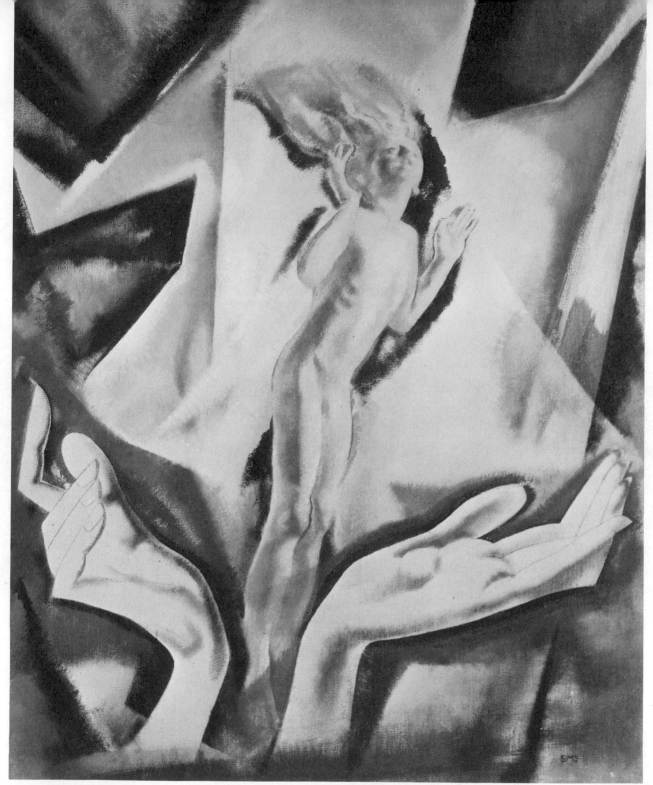

50. CHARLES SIMS. *Lo, Here Am I*. Oil on canvas. 36" x 28¼". 1928. Courtesy of the Cleveland Museum of Art, the Hinman B. Hurlbut Collection, 1929.

It must never be forgotten that our interest in a work of art is our interest in the quality of the mind that went into the making of it.

Charles Sims

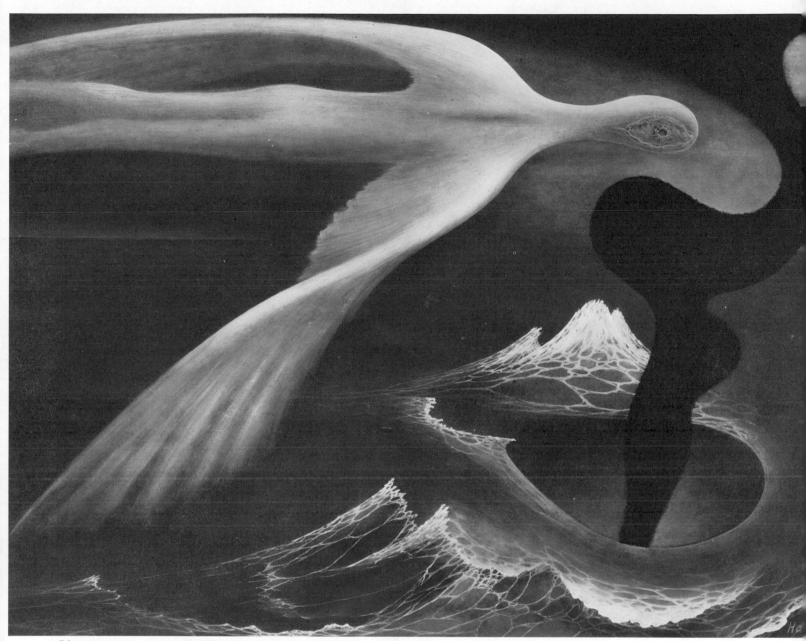

51. FREDERICK HAUCKE. *The Black Shape of Madness.* Oil on board. 18″ x 24″. 1948.

In marbled stature stands that upright stalk called Man
Grown tall; and then like willowing tree, he falters to
Become a horizontalled twig within the crust of mother earth.

That graveyard plot becomes alchemied in its pallbearing rite;
And in that frozen pit called death, that former ball of fiery
Furnace casting off its sins as poisoned fangs, retires the ego
To diaphanous flying egg; the moment comes for life's rebirth!

The mysteries of life, how life comes forth from out that
Bottomless Pit, the grave, are writ within the cell, as soul;
It seals its cancered crown of thorns, its suffering anguished
Thought, that reconditioning train of memoried joys and agues ached,
Within reincarnation's well of wintering waters, the memory vaults.

"Death"
by Paulina Peavy

84

52. PAULINA PEAVY. *Death*. Oil on gesso board. 14″ x 12″. 1940.

53. PIERRE MALUC. *Disincarnation (Death).*
Scratched paper. 14½″ x 10″. 1954.

Terrestrial life is an unstable and intermediate period.

Pierre Maluc

54. ELIZABETH FARKAS BRUNNER. *Cosmic
Beginning. Death—Darkness to Light.*
Oil on canvas. 41″ x 51″. 1934.

55. JOHN FARLEIGH. *In My End Is My Beginning.* Wood engraving. 18¾″ x 12¼″.
Courtesy of the Prints Division, The New York Public Library.

The complex problem of beauty is bound up with the problem of truth, and I
cannot separate them.

John Farleigh 87

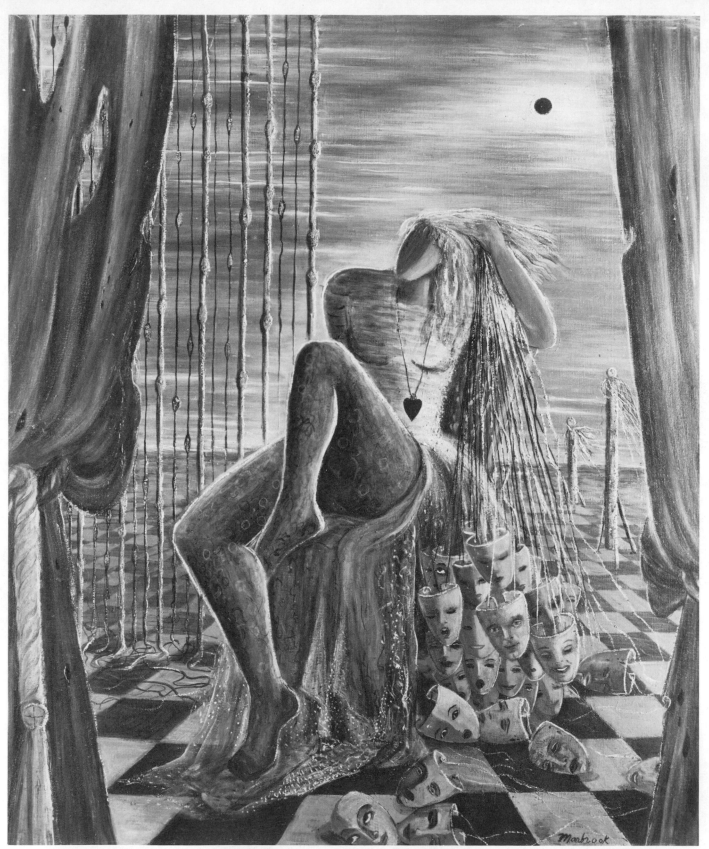

56. JUANITA MARBROOK-GUCCIONI. *She Had Many Faces.* Oil on canvas.
32″ x 38″. 1948.

For guidance to fulfill our destiny we can call reverently on the universal
power, even though it may be beyond our understanding.

Juanita Marbrook-Guccioni

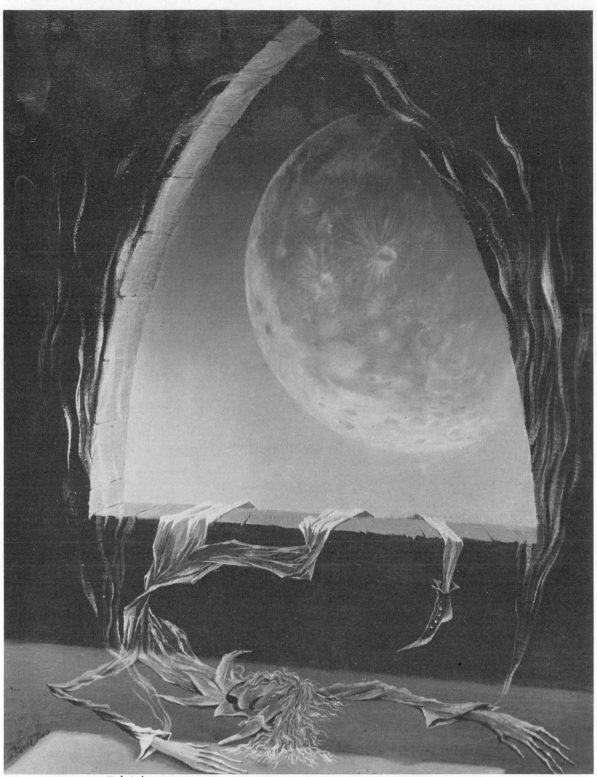

57. PIERRE INO. *Déchéance: Death and Resurrection.* Oil on canvas.
13¾″ x 10⅓″. 1946.

Death is not ultimate but rather is a liberation, an elevation from the
corporeal to a spiritual state.

Pierre Ino

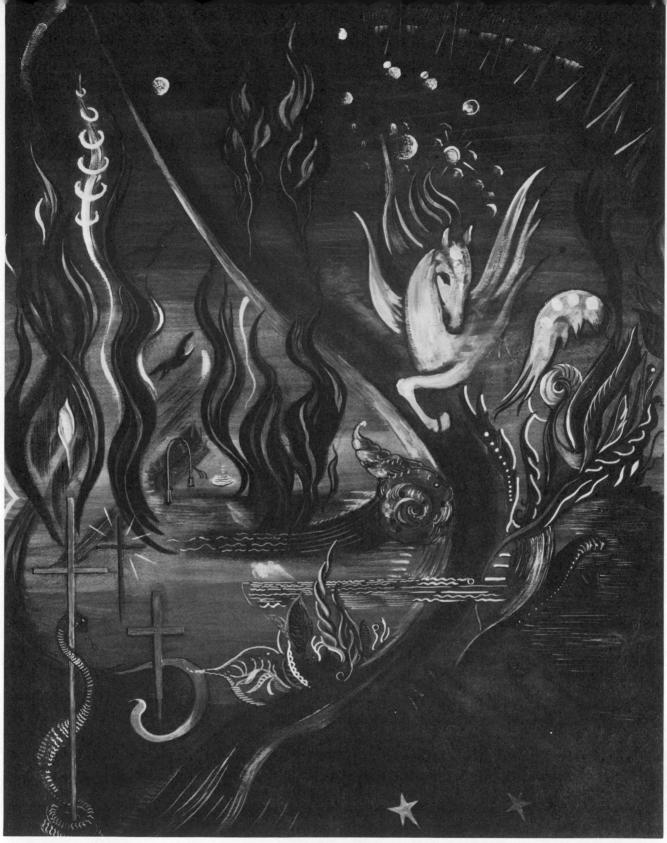

58. LORRAINE STARR. *Life, Death, and Transfiguration.* Tempera on paper.
16" x 21". 1947.

Subconscious—psychic or spiritual—images cross my mind, and those that
disturb me most remain to be recorded.

Lorraine Starr

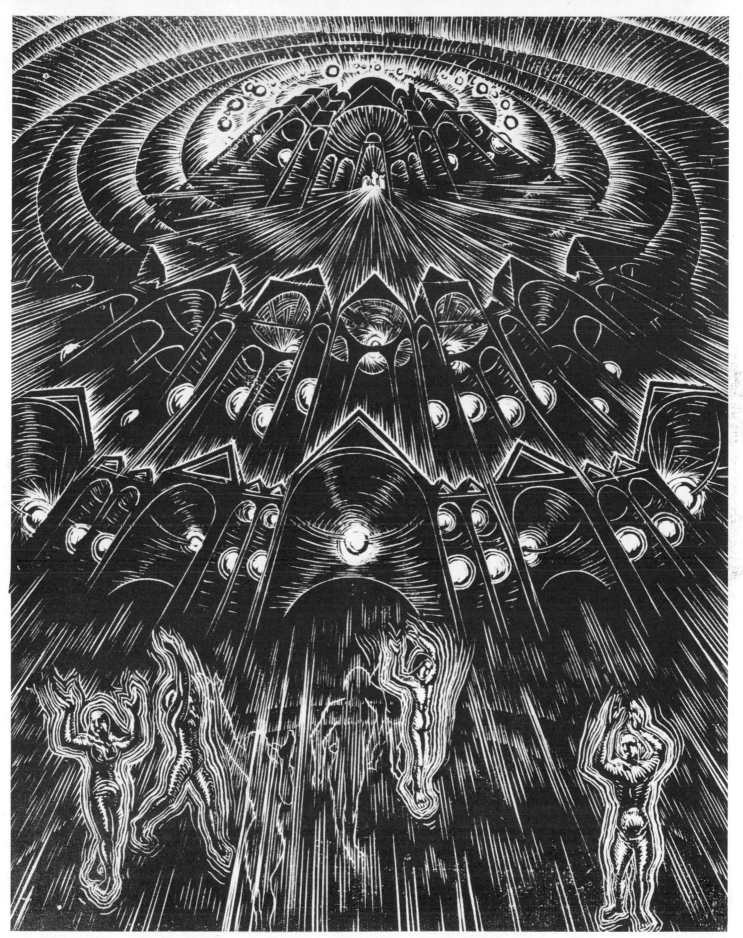

59. GUSTAV WOLF. *Cosmic Architecture*. Wood engraving. 11″ x 14″. 1947.

This idea of death or departure is echoed by Pierre Ino, who in his *Déchéance: Death and Resurrection* (illus. 57), creates a poetic image of death. He states that death is not ultimate, but rather is a liberation, an elevation from the corporeal to a spiritual state. Placeless and timeless, a human being is in the process of disembodiment and of reunion with the infinite. It is both night and day. The clownish, ghostlike envelope is slowly consumed. From the sleeves, wispy flames, symbol of spirit, ascend to join a passing heavenly body. The egg form of the composition symbolizes the continuity of existence. And in *Disincarnation (Death)* (illus. 53) by Pierre Maluc, figures and faces appear which suggest the universes of transparent ghosts, spirits, or disincarnated beings springing up in the night.

Cosmic Architecture (illus. 59), by Gustav Wolf, suggests the invisible structures of the nonperceived universe, the cosmogenesis that lies just outside the awareness of all, awarenesses that become available upon deliverance from the material confines of ego. (See illus. 63, *Deliverance*, by Einar Jonsson.)

Man's preoccupation with the material is always underpinned by his unconscious conception of the immortal and the spiritual, as indicated in *Idol of America* (color plate 13) by Philip Moore, who gives us, in a single picture, a cosmic comment on the orientation of an entire mechanized age of autos. In *Aspiration* (color plate 13, bottom) the same artist conveys succintly man's urge to aspire, to reach upwards through storm and lightning bolts and even through a *Trial by Fire*—(color plate 12) by Maulsby Kimball. Kimball's art, and the flowing, ethereal qualities of his medium (watercolor) blend like musical chords, exquisitely bringing forth that rich, abstract, interpenetration of meanings that distinguish cosmic values.

Deep in every man abides the paramount desire for a more abundant life, however unwitting, fragmentary, or self-defeating may be his notion of it. Men want that copious good of many names: happiness, freedom, holiness, eternal life—any victory over the multiple evils that beset life.

The term "self-realization" has the distinct advantage of indicating that the good life is both a process and a direction. Beyond all other arts is the final art of being. To be—beautifully! This is a goal of highest destiny and a clue to our eternity.

A variety of natural and psychological drives seem to impel the human self to aesthetic pleasure and artistic creation, demonstrating the dynamic reality of reflective, subjective, even psychic art. Man's dependable motives may be described as a fourfold hierarchy of decreasing dependability. These motives are man's ancient instincts, which continue to operate under new names. The highest class includes "absolutely dependable" drives that every man will have without exception. Though sex and maternal behavior are in a second class, the first class includes, along with hunger, thirst, sleep, and so on, the aesthetic drives, those drives that are inescapable affective responses that man makes to sensations of eye, ear, and rhythmic behavior, the basic senses that function in the fine arts.

Aesthetic value, or beauty inclusive, is known to all men, loved by them, and rooted in their deepest nature and need.

60. HENRI FRUGÈS. *The End of Humanity*. Oil on canvas. 89 cm. x 116 cm. 1951.

61. LEO KATZ. *Metamorphosis 1942*. Oil on canvas. 8' x 15'. 1942.

62. REVA REMY. *Spiritual Gestation, Struggle for Light.*
Gouache. 14″ x 22″. 1957.

How man, endowed by the Almighty with talents and abilities, attempts to develop them so as to enable him to make it easier in the struggle on earth to reach those aspirations that will better his fellowmen and make it a more desirable world to live on. And how he attempts to satiate the yearning within the soul to reach out and touch that something he knows not what, but which is there to be obtained, if only he can hold on with faith, hope, courage, intuition, and the fire of enthusiasm.

Philip Moore

I have always considered my drawings as mere blueprints or patterns of the infinite beauty and order in and behind any soul-viewing of the symbol. That others may find in them a link—that is all one asks.

Sylvia Leone Mahler

I seem to detect the harmony of beauty everywhere, and I want my voice to be in tune with the voice universal and to sing the hymn of praise in my own way without too great dissonance on my part.

Einar Jonsson

It seems to me that one of my primary objectives in art activities has been to induce the viewer to think—not necessarily to think in agreement with my creations, but to be shocked, stirred, angered, mystified, agitated, thrilled, amused, outraged, satisfied, stimulated, irritated, or pleasantly soothed into thinking according to his own inclination. The stimulation of creative thinking in individuals, it seems to me, is one of the most important objectives toward the cosmic fitness of mankind.

Blanding Sloan

63. EINAR JONSSON. *Deliverance.* Plaster. 80″ x 80″. 1933–1946. Courtesy of the National Einar Jonsson Museum, Reykjavik, Iceland.

Yet, another fundamental answer to the question as to why men do crave cosmic art goes beyond natural, or physical, explanation into man's desire to be drawn towards the infinite, the nonmaterial, the psychic, and the metaphysical. The world of consciousness, intimating things beyond the merely physical, demands access to those worlds—essentially through experience, but explicitly through cosmic aesthetics, valuable works of art that become aids for transcendental awarenesses.

Art, then, is not for art's sake, as has so often been pandered about, but for man's sake, for man's self-unfoldment and delight, for a more meaningful and joyous existence. To say that art is for art's sake is nonsense, since the assertion omits the bearer of values, the seeker, without which there is no sake.

The fine arts, and now cosmic art, are superb examples of the affirmation of creative life and the joy of fulfillment. Artistic creation is the outcome of the whole nature of man so far as it is developed in the artist, and cosmic art is the most satisfying because in its various expressions it combines both subjective and objective aspects of man's major problems and purposes. It appeals to and satisfies, step by step, man's whole self. The various values manifested in art that is cosmic are phases of the drives underlying all others, the demand for wholeness of life, for metaphysical or total salvation.

Man is hungry for the infinite.

It is to the responsibility to spiritually enrich through what we create that the artist who would serve the future is called upon to dedicate himself and his art. This calls for the transformation of his plastic language and of his vision so that it will be more life giving. It necessitates the self-transformation of the being of the artist himself.

Maulsby Kimball

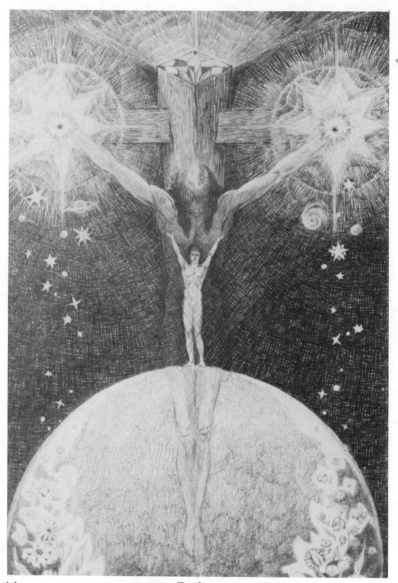

64. SYLVIA LEONE MAHLER. *Redemption.* Pencil drawing.
9¼" x 6¼". 1941.

I have attempted to portray, in the fifty or more drawings I have made, something of the mysterious, divine universe and something of the joy and triumph, as well as the loneliness and grief, of man's hazardous journey through it.

Sylvia Leone Mahler

5

BEYOND AND BEYOND

65. BUELL MULLEN. *Youth Seeks the Far Galaxies.* Epoxy paint on stainless steel. 38' x 10'. 1958. Courtesy of Case Western University, the Strosacker Physics Building, Cleveland.

At each moment of time there are not only new forms evolving, new forces manifesting, but also a constant movement of involution, of forces descending into life from more subtle levels of being. Those most vital and easily perceivable are ideas, artistic creations, new forms, discoveries, deriving from the psyche and the psychic in man, resulting in more spiritual and encompassing goals. Art speaks directly to the feelings, perceptions, and sensibilities and has a capacity of reaching people without intermission. It has an unequaled potential for response. And amongst the responses will occur one that means much to the individual—a sense of worth as an individual and an appreciation of cultural heritage that spontaneously will move into community development and deeper understanding of spirit.

Buell Mullen

Each work of art that the artist or the viewer senses is cosmic expresses a conscious relationship between the artist and an important aspect of reality or value. Such linkage presupposes a new and successful inroad or penetration of some threshold of potentialities that can be called psychic or transcendental frontiers.

These thresholds lead to endless sources of adventure and inspiration, of evaluations and themes for artistic creations that may be of great and permanent worth to mankind. Besides the perceptual, objective, and material frontiers that have been referred to already, there are also the value frontiers of the social, the subliminal, the psychic, the transcendental, of higher awarenesses and the personally religious.

As artists of recent times have begun to push inroads into other areas of human interest outside the perceptual and the material, much of the understanding of art has become confused. In correspondence, the artist Alice Boner summed up this contemporary quandary.

> I cannot bring myself to believe that art by itself could have the power of bringing about any spiritual revival. Art never is the prime mover but always the outcome, the noblest and most significant expression of any spiritual movement or system of thought. In our times, when there is no such fundamental philosophy of sense of metaphysics molding our lives, when we are all groping in the dark in different directions, the efforts of the individual artist are no longer connected with the central root and therefore understandable to all but must needs be the expression of his personal longings and aspirations, or maybe of his personal philosophy.

In times past when human culture did rest on solid metaphysical foundations, when life and art were an integrated whole, no fragmentary, chaotic, and irrelevant art could ever have been produced. Neither would there have been any need of a special category of artists, which you call cosmic artists, to remind people of their spiritual or transcendental need. Then all art was cosmic art, even the making of a chair, a door, or a safety pin. Everything had a meaning before it had a practical use. Nowadays everything has a use, but nothing has a meaning or value.

When therefore a few artists feel the urge to create for expressing a meaning, they are in truth expressing the desperate longing of our age for that spiritual heritage that is ours by right from the beginning of the world, but whose lifeline was snapped by modern enlightenment before we were born. Under the destructive sway of materialistic, scientific civilization, all we can do and must do is to follow our inner voice, work according to its command as well as we can, without worrying about the consequences of the future, victory or defeat.

Value transcendentals are an inexhaustible resource for realizing human desires. They embrace all existing realizations of human interests and are emotional, desirable, sharable universals. We call them ideals before we realize them, and norms if we attach importance or weight to them.

Social transcendentals emphasize the endless gifts that other minds, past and present, may share with us if we justly share the conditions of receptivity and reciprocity. The most profound, terse, and persistent truth is that self and society are twin-born. The individual cannot become human by himself. Solitude is not productive without the act of communicating. Communication is the desperate necessity. Self-being is only real in communication with another self-being. Alone, one sinks into the gloom of isolation.

Subliminal and psychic transcendentals point toward the immeasurable vastness of man's latent capacities at many levels of possible unfoldment. Here belong the nearer realms of subconscious potencies, all traces of new and ancient memories, divine deposits, racial instincts, and perhaps even vestiges of previous incarnations. Beyond these lie the mysterious higher realms of consciousness—realized by few men, it seems.

One of these men, Sri Aurobindo, has written:

Our momentary personality is only a bubble in the ocean of our existence . . . a trembling ray on the surface. Behind our waking consciousness, much vaster than it, there is a subliminal or subconscient mind which is the greater part of ourselves and contains heights and profundities which no man has yet measured or fathomed (18).

Profound awareness of these vast, unexplored continents of the subconscious mind has also been of concern to the eminent Western sociologist Pitirim A. Sorokin, who indicates:

> Today the total reality is thought of as the infinite X of the numberless qualities and quantities: spiritual and material, temporal and timeless, ever-changing and unchangeable, personal and super-personal, spatial and spaceless, one and many. . . . Even substance, quantity, quality, relation, time, space, subject-object, cause-effect, being-becoming, can identify the ripples of this ocean, but are inadequate for definition. . . . This explains why many have called it "the unutterable," "the inexpressible," "the divine nothing" into which fade all things and differentiations. . . . According to this new integral theory of knowledge, we have not one but at least three different channels of cognition: sensory, rational and supersensory-super-rational. . . . Glimpses of the super-rational-supersensory forms of reality are given to us by intuition, divine inspiration or the flash of enlightenment of all creative geniuses: founders of great religions, sages, seers, prophets and teachers, scientists, philosophers, artists and leaders in all fields (19).

Any philosophy of the cosmic might include a reasoned-intuitive account both of the higher worlds or planes of existence and of ways to reach them. The self must break through a succession of sheaths, fences, or veils to attain psychic or cosmic consciousness and the life divine. The intervening regions are the physical, the vital (animal desires and ego), the mental (reason), and the spiritual or supramental. It is through the developing powers of psychic consciousness that the self establishes communication with other planes.

It is the inner being in reality, and not the outer mind, that possesses the powers of telepathy, clairvoyance, second sight, intuitive flashes, and other supernormal faculties. Let us earnestly hope that these mysterious realms will increasingly provide important themes for cosmic art as psychic persons become good artists and good artists develop their psychic capacities.

All of the artists included in this book have, in their special experiences, acceded aesthetically to portraying events and topics which, if they are related to the perceivable, have their source, their inspiration, from other places.

In executing her enduring mural *Youth Seeks the Far Galaxies* (illus. 65), Buell Mullen prophetically portrayed the unlimited horizons of youth in the eternal quest for knowledge, a quest that characterizes youth movements throughout the world today. The result is a striking semi-abstract, with the head of a youth as the central figure. Surrounding him, much in the fashion of electron paths about the nucleus of an atom, are lines representing encircling lines of thought and possible extensions of awareness. The background is an imaginatively sketched periodic table of the chemical elements and of the galaxies representing the great potential of human knowledge.

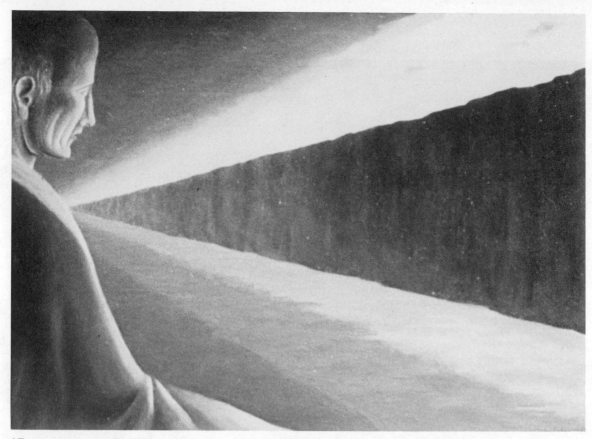

67. JEAN LAFON. *Le Mur du Monde* (*The Wall of the World*). Oil on canvas.
61 cm. x 46 cm. 1945.

Towards an Archetypal Anatomy of the Soul (illus. 77) by Helmut Zimmerman suggests the immortal residing in the material. The artist states:

> One may begin the understanding of this painting by regarding it as an X-ray film that presents the frontal view of a standing human figure. It is an interpretation of human nature in terms of latent and active centers of psychic energy that lie along man's vertebral axis. It is an attempt to represent not man's outward appearance but what he perceives or feels to be his existing self as he looks within. Every particular resulted from something I felt within me.

The availability of subliminal and psychic awareness is brought into aesthetic composition by *Meditation* (color plate 14) by Elizabeth Farkas Brunner, and *Presence* (illus. 76) by Gustav Wolf. Psychic perception of other planes or dimensions are visualized in *A God of the South Pacific* (illus. 78) by Ethelwyn M. Quail, in *Magnitude* (illus. 75) by Sylvia Leone Mahler, and in *Avatar* (illus. 79) by Dane Rudhyar. Rudhyar, like Zimmerman, indicates that the basic idea of the picture is to describe the fully developed "in-spirited" man in terms of the symbolic patterning of inner forces rather than in terms of outer material appearances.

The lovely ink drawing, *Release* (illus. 87), by Margaret E. Martin, intimates the fabled out-of-body experience, as does the beautiful *Flight over the Ocean* (color plate 1) by Gerardo Dottori.

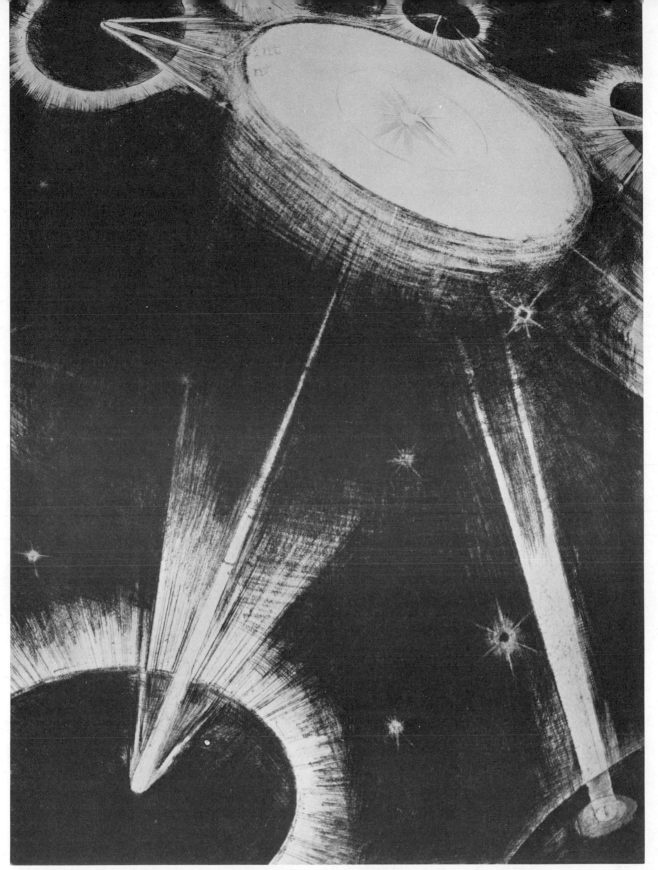

68. WILLY JAECKEL. *Creation*. Drypoint etching. 11½" x 15½". 1920.
Courtesy of Dr. Peter Jaeckel.

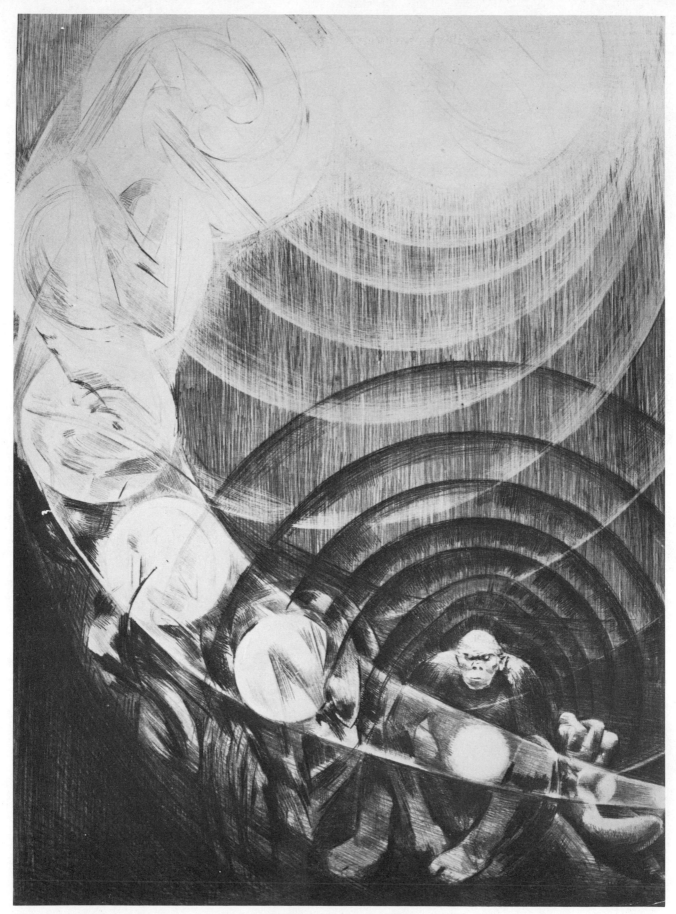

69. WILLY JAECKEL. *Evolution*. Drypoint etching. 11½″ x 15½″. 1920.
Courtesy of Dr. Peter Jaeckel.

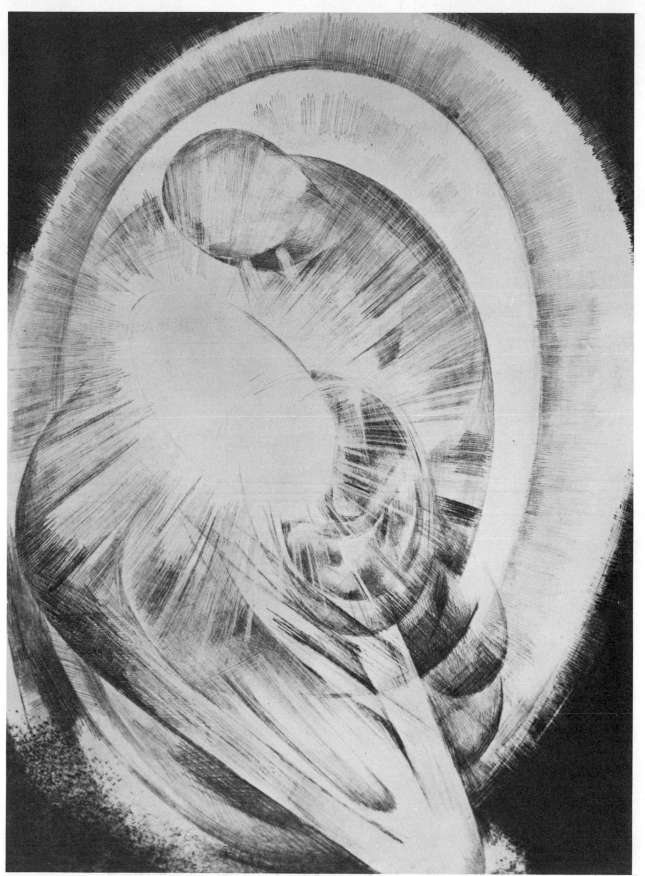

70. WILLY JAECKEL. *Illumination*. Drypoint etching. 11½″ x 15½″. 1920.
Courtesy of Dr. Peter Jaeckel.

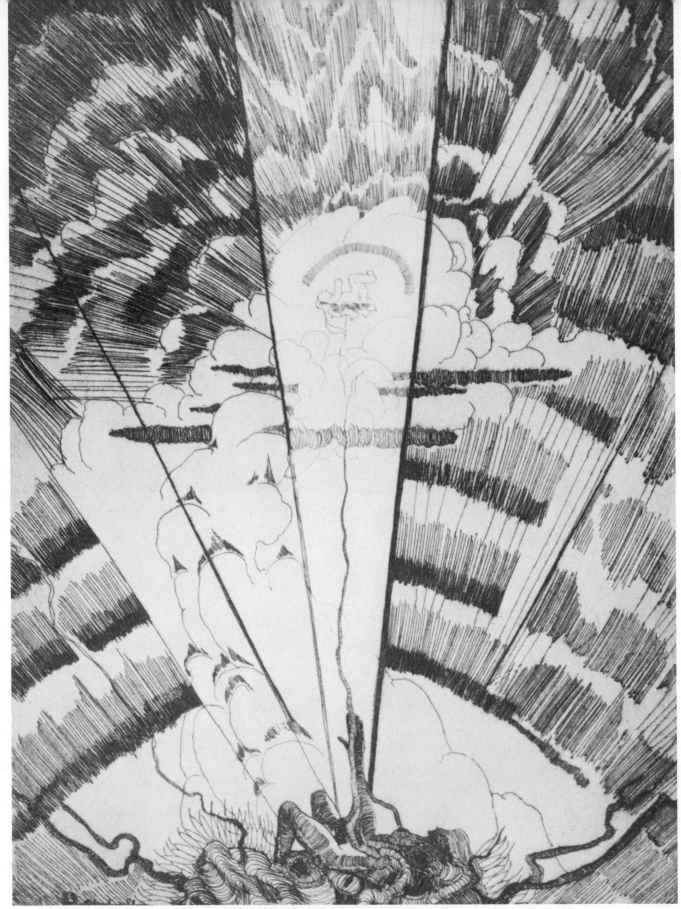

71. BLANDING SLOAN. *Mother*. Pencil drawing. 10″ x 13″. 1930.

72. BLANDING SLOAN. *Walk through the Gates*. Line etching. 9″ x 11½″.
1934.

Mankind is slowly developing extrasensory perception through repeatedly being exposed to indivisibles that are a part of individual people for a while but at other times are part of extrasensory combinations.

Indivisibles are so minute in their uncombined state that they are as nothing to the five senses of mankind. Only a few of the limitless possible combine to register on man's limited senses.

The physical is that part that is touchable by man's physical senses— and is provable by physical means. The spiritual, or the psychic or the supraconscious, is that limitless part of the cosmos that is not receivable by mankind's at present limited senses.

Blanding Sloan

The legendary psychic potential of prophecy has often and in many ways been brought into aesthetic view. A particularly poignant rendering is that of the portrait by Leo Katz of the former, respected science editor of the *New York Times*, Mr. William Laurence (illus. 83). This portrait was painted in 1939, several years before the atomic bomb was first exploded. It shows a pensive man, contemplating some of the mysteries and grandeurs of existence. As was usual with Katz, in organizing the portrait he allowed subliminal or psychic intimations to arise in the work, a method that characterizes many psychically inspired artists.

Katz felt inspired to include in the background a view of a galaxy, intimating unconstrained power, and at the upper right the early formulas of the quantum constant from Einstein and the Heisenberg formula of the principle of uncertainty, as well as some scenic destruction on land and sea. All these potentials, universal power, formulas, and destruction, went into and were the result of the atomic bomb, physically unknown in 1939, the year of the portrait.

Six years later, Mr. Laurence was the first and only member of the press to be allowed to board a certain secret airplane for a mission unknown and therefore the first to report firsthand the effects and magnitude of the nuclear device dropped on Nagasaki. It was from the pen of the pensive man in this portrait who, viewing universal power and earthly destruction, first gave the world the words "like many suns," a vision of the man clearly and correctly portrayed by Leo Katz several years before.

The themes from cosmic artists run in many directions and are varied. Cosmic humor is perhaps the most rare of themes, a sense that is reflected pleasantly and meaningfully in the two works of Pierre Ino, *Cosmic Visitors #4* and *#5* (illus. 84, 85). But whatever the thematics of individual artists, the creative artist who is philosophical may think, feel, and execute visions of the fleeting intimations of that something beyond everything, a sense of higher destinies that draw men ever onward.

Religious frontiers of consciousness have been the major sources of themes and inspiration in the long history of art. The religious threshold refers to all fresh, living contact with a sense of life purpose, organic wholeness, or often a sense of a cosmic mind, the ceaseless sustainer of the total universe, visible and invisible.

Sylvia Leone Mahler contemplated the totality of the universe, enabling her to render to paper with pencil symbolic religious drawings, among which were the *Alpha* (illus. 73) and *Omega* (illus. 74) of existence. The strange, compelling craftsmanship and aesthetic sense of Serge Ponomarew draws the viewer nearer to omnipresent spirituality with his creation *Trinity* (illus. 80–82).

73. SYLVIA LEONE MAHLER. *Alpha.* Pencil drawing. 9" x 12". 1936.

74. SYLVIA LEONE MAHLER. *Omega*. Pencil drawing. 9″ x 12″. 1936.

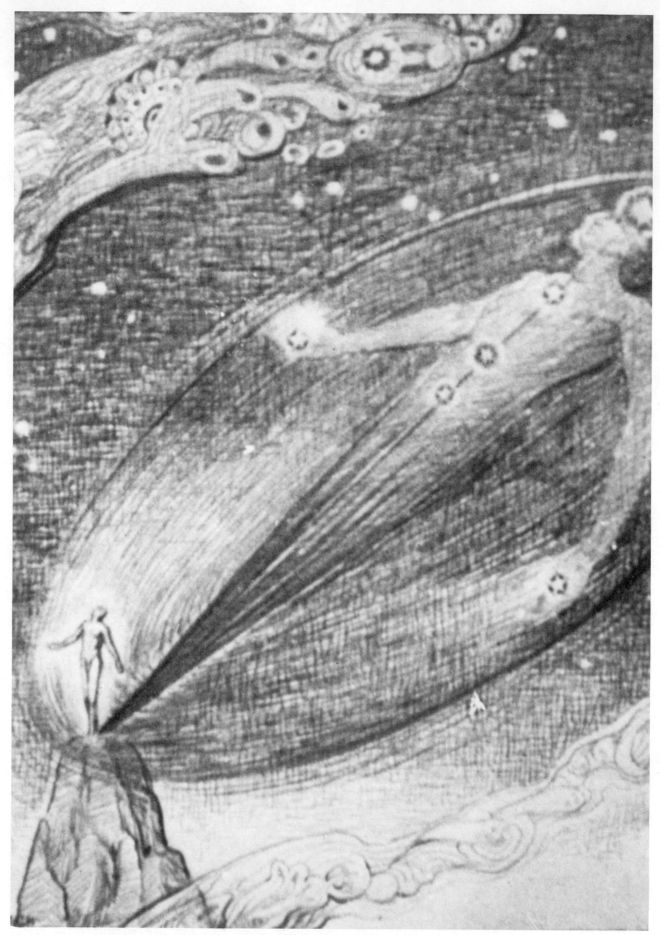

75. SYLVIA LEONE MAHLER. *Magnitude*. Pencil drawing. 9″ x 12″. 1936.

Did you they laud, source of the vast creation's
Immutable iron laws,
From mothers learn true tenderness, from martyrs
Joy in a sacred cause?

The faithful soul, cowed by stupendous numbers
Now must perforce accept
The spilth of shattered suns, the wasteful cosmos
And wrongs the ages wept.

In your abysmal past, knew you not pity,
Lord of leviathans
Cuirassed and fanged, affrighting gentle species,
Pity that late is man's?

Shall the sky speak, the voice find lips to answer
When man interrogates?
Shall he possess the key, make plain the enigma
Of his own transcending states?

And yet burn candles, garb the shrines with lilies
And murmur childlike prayers
Or twist such intricate argument as dallies
In ancient faith's despairs?

"The Unanswered Question"
by Louise Janin

76. GUSTAV WOLF. *Presence*. Wood engraving. 11½" x 14½". 1947

77. HELMUT ZIMMERMAN. *Towards an Archetypal Anatomy of the Soul.*
53½″ x 63″. 1960.

78. ETHELWYN M. QUAIL. *A God of the South Pacific.* Tempera. 18″ x 24″. 1940.

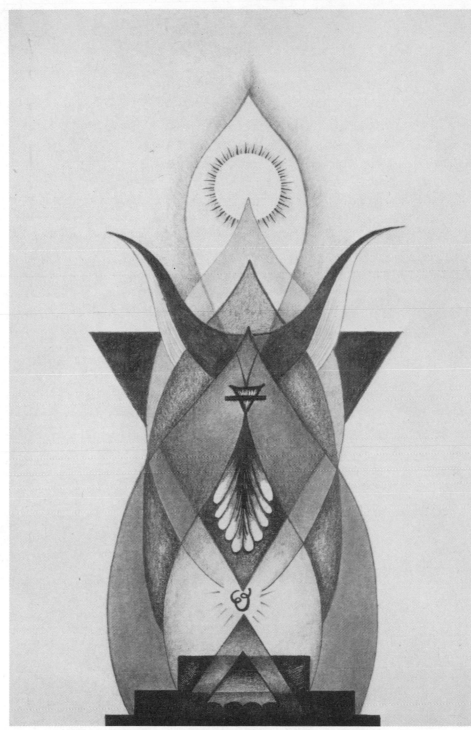

79. DANE RUDHYAR. *Avatar*. Pencil, ink, and watercolor. 7" x 10½". 1938.

I am–life forever becomes toward the perfect experience of ever more inclusive wholeness.

Dane Rudhyar

Only by intuition can the artist attain the energy of creation and the light of the cosmic presence. Intuition is the creative grace or gift of psychic or immediate knowledge that arises in human consciousness and is transformed in vision and the power of images. It is important, therefore, for the artist to know how to listen to his inner voice and to develop a highly sensitive and spiritual intuition, lest demonic and aberrated forces sneak into his creations. The artist humanizes that which is divine and consequently makes divine that which is human.

Serge Ponomarew

SERGE PONOMAREW. *Trinity*. Three-sided sculpture (illus. 80, 81, 82). Plaster. 20" high. 1949.

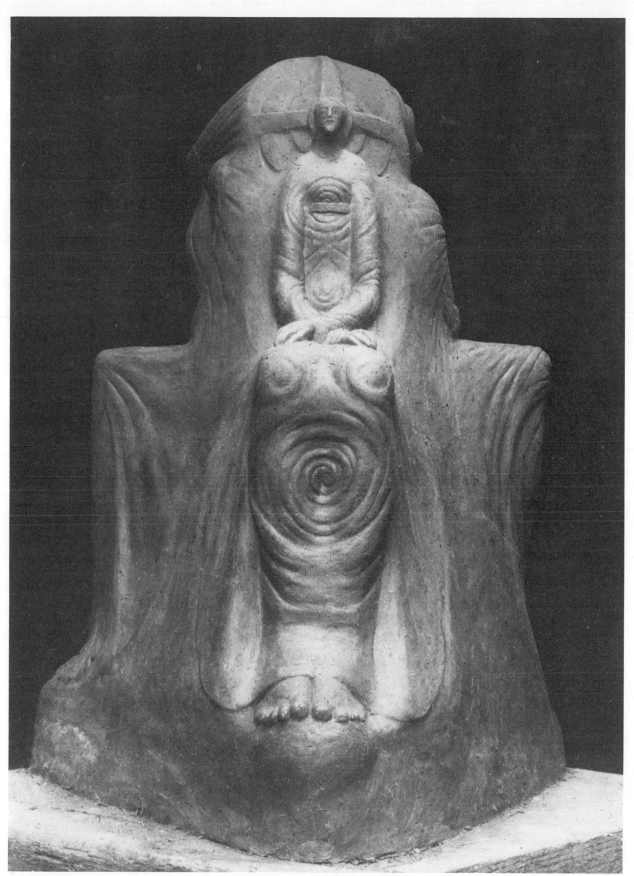

80. *Christ*

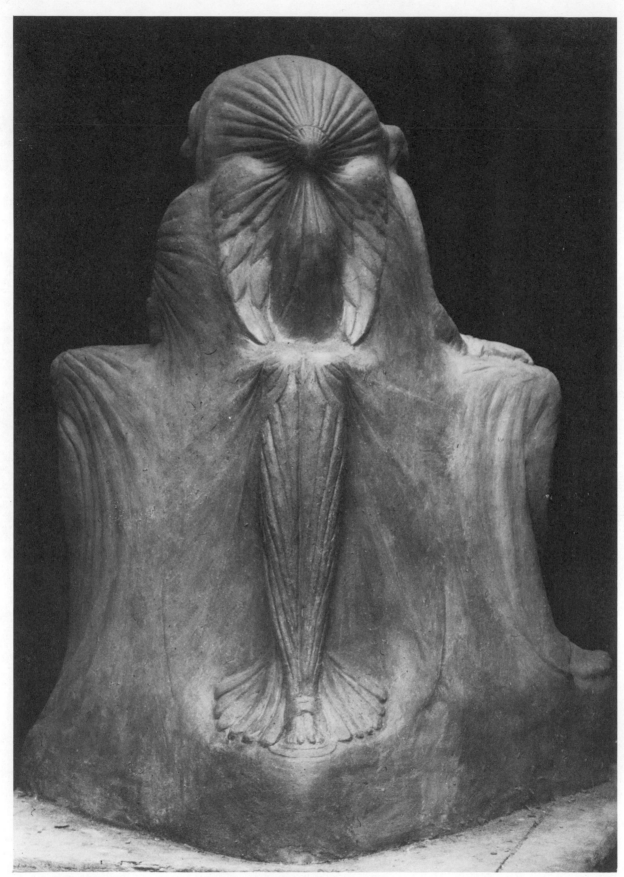

81. *God the Father*

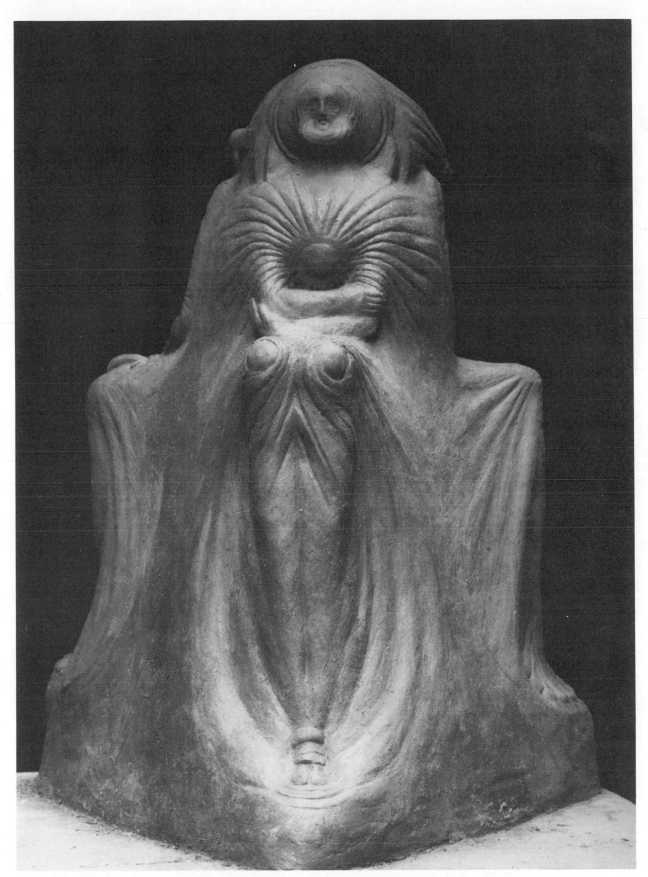

82. *Holy Spirit*

83. LEO KATZ. *Portrait of William Laurence, Science Editor of the New York Times.* Watercolor. Life-size. 1939.

So much knowledge and technical equipment seems to turn into a fatal trap that will destroy us, unless we become ready to receive those light rays that could guide us from chaos towards a true mastery of the forces within ourselves and of the instruments we have brought into existence.

Leo Katz

84. PIERRE INO. *Cosmic Visitors #4.* Oil on canvas. 22" x 18". 1967.

85. PIERRE INO. *Cosmic Visitors #5.* Oil on canvas. 32" x 26". 1966.

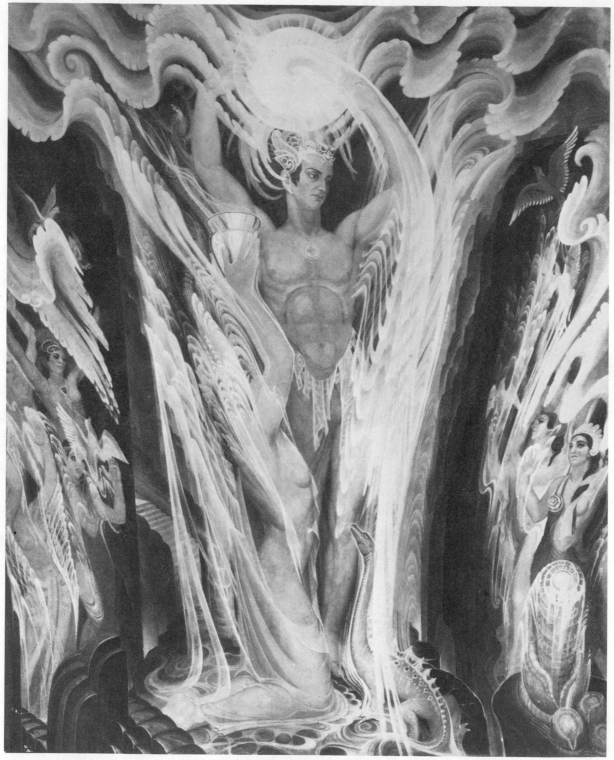

86. LOUISE JANIN. *The Marriage of Fire and Water*. Oil on canvas.
54½″ x 48″. 1948.

I am an idealistic agnostic, and I like the neoplatonic formula. But I have long since quieted such feverish questionings of the origin of things with this personal definition of the absolute: that which is, is, because it could not not have been. This gives me ultimate hope and confidence.

Louise Janin

130

Alone
In cloak of light
I walk the starry realms,
In perfect peace
I tread the spheres
Released.

"Release"
by Margaret E. Martin

87. MARGARET E. MARTIN. *Release*. Ink.
10" x 14". 1946.

88. RUTH HARWOOD. *Beyond the Stars*. Ink. 12" x 18". 1953.

Beauty itself is a gospel, a radiance that encircles the world like a halo. It is a current, luminous and everlasting. Nature, moving in her rhythms through the earth, flows into the substance of this current. And art, whose very utterance becomes a testament of man's spirituality, is a portion of this never-ending stream. All great art is a bridge to the beyond. It is an urging of man's soul to a higher, better world of being— a world that we are given the power and command to create on earth.

Ruth Harwood

132

89. PARMANAND S. MEHRA. *Cosmic World*. Watercolor. 15" x 20". 1954.

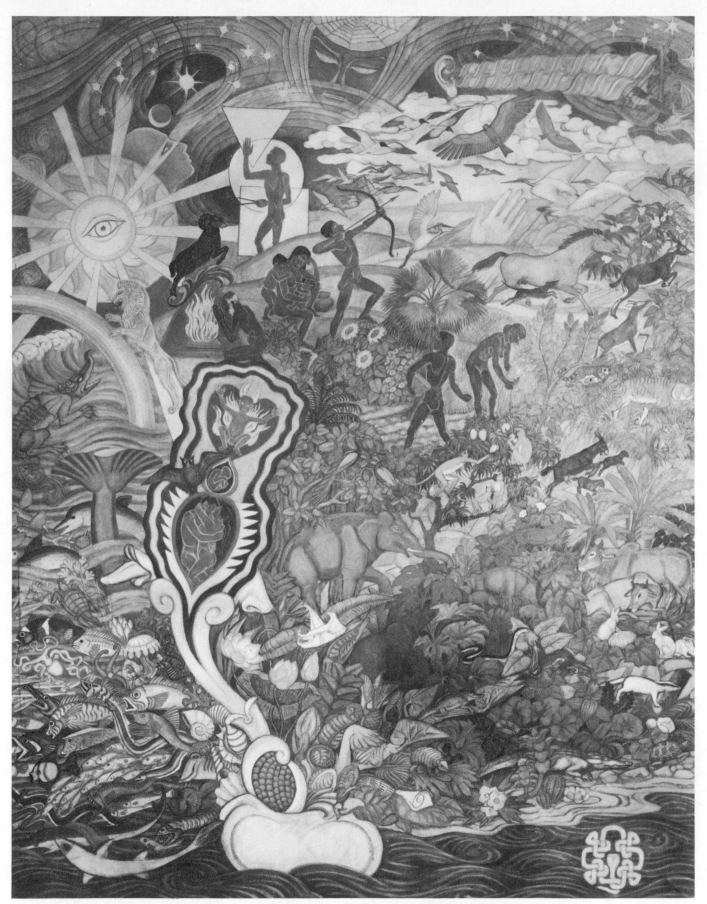

90. ALICE BONER. *Creative Evolution*. Oil on canvas. 80″ x 60″. 1959.

The awe of creation is expressed in *Cosmic World* (illus. 89) by Parmanand S. Mehra, and in *Creative Evolution* (illus. 90) by Alice Boner. The latter is an image that appeared to Boner in a sudden vision on a sultry, rainy afternoon. She perceived all creative things emerging with a vertiginous rapidity from a white womb that floated on deep dark waters, rising up, unfolding, and then dissolving into nothingness. In the painting the forms are necessarily fixed, and their unending movement out of the womb of time remains discernible only in their upward striving lines.

The religious and psychic presence, in a sort of humanistic altruism, is source for unimaginable beauty in the minds of artists everywhere. This potential, metaphysical as it is, is ever the substructure of the inquiring, yearning mind and spirit of man. In *Beyond the Stars* (illus. 88), Ruth Harwood constructs a delicate, eternal drawing.

> The bridge of nature forms with many lines that echo one another, as the trees and clouds, clouds and birds, stylized dog form of faithfulness, echoing lower line of human body, all weaving and interweaving of one cosmic pattern through the earth. Mankind, the valiant disciple on the bridge, can take the whole gamut of vibrations from the earth and project them into his own creations of immortality beyond the stars. Out of the universal current rises the tablet of his creation, positive and negative polarities, the essence of perfect balance and key of the eternal in the midst of time.

Seers, psychics, and artists have given us, if we would but listen and see, a rich treasury of insights into mysterious realities. Every revelatory artist gives abundant testimony to the existence of another dimension of life, to which his work is only a kind of inspired footnote. Cosmic art is a kind of hawser that draws us into wonderful realms that we have not seen before, which are not seen with our own eyes.

The universal concepts that illuminate the greatest reaches of reality are metaphysical. They are the most general and fundamental predicates of being, without which being could not be. And the human self does not float on a stream of temporal or visual tonalities; but, like an anchor in a rushing river, it defies time, seizes temporality itself, and transforms it into the total continuity that makes for cosmic enjoyment.

It is the psychic self which, in the fine arts, builds those precious blends of highest beauty.

> The striving for the artistic formulation of cosmic conceptions is, for the artist who produces the work, at the same time a striving for inner realization. He may never reach his goal, but there is no doubt that the work itself is benefiting him, by deepening and widening his feeling of cosmic relationships.
>
> *Alice Boner*

91. BERNARD O. WAHL. *Aurora Borealis.* Oil on canvas. 24″ x 28″. 1940.

92. JEAN PICART LE DOUX. *Man and the Universe.* Tapestry. 79" x 118". 1949.

The marvels of creation remain as inexhaustible and magnificent as on the first day.

Jean Picart le Doux

NOTES

ONE

1. E.S. Brightman, *Nature and Values* (Nashville: Abingdon-Cokesbury, 1945), p. 52.
2. Paul Tillich, Lecture at Syracuse University, December 1, 1960.
3. Ivan Meštrović, in *Time* (April 14, 1947), p. 53.
4. André Malraux, *The Voices of Silence*, translated by Stuart Gilbert (New York: Doubleday, 1953), p. 153.

TWO

5. William Ernest Hocking, *Preface to Philosophy* (New York: Macmillan, 1946), p. 413.
6. Fyodor Dostoevsky, *The Brothers Karamazov* (New York: Modern Library, 1943), p. 450.
7. O.L. Reiser, *Scientia* (July–August, 1954), p. 10.
8. Christopher Caudwell, *Illusion and Reality* (New York: International Publishers, 1937), p. 294.

THREE

9. Charles Biederman, *Art as the Evolution of Visual Knowledge* (Red Wing, Minn.: Art History Publishers, 1948), p. x.
10. Margo Hoff in "Biographical Notes," *Exhibition of Contemporary American Painting, 1955* (Urbana: University of Illinois), p. 207.
11. Lynda McNeur, *Space, Time, and Spirit*, p. 13.
12. Malraux, *The Voices of Silence*, pp. 312, 334.
13. Christopher Gray, *Cubist Aesthetic Theories* (Baltimore: Johns Hopkins Press, 1953), p. 76.
14. Leo Manso in "Biographical Notes," *Exhibition of Contemporary American Painting, 1955* (Urbana: University of Illinois), p. 219.

15. Hans Hoffman, in *Search for the Real and Other Essays* (Andover, Mass: Phillips Academy, Addison Gallery of American Art, 1948), p. 46.
16. Henri Delacroix, *Psychologie de l'Art* (Paris: Presses Universitaires de France, 1927), pp. 89, 447.

FOUR
17. Harry Emerson Fosdick, *Living Under Tension* (New York & London: Harper), p. 50.
18. Sri Aurobindo, *The Life Divine* (New York: Dutton, 1949), pp. 203, 497.
19. Pitirim A. Sorokin, "Three Basic Trends of Our Times," in *Triad*, 2: no. 1 (1961), 10–11.

SELECTED BIBLIOGRAPHY

The list of references that might be associated with any concept pertaining to things cosmic would be enormous. This bibliography is therefore not meant to be complete. The sources listed have been compiled in an effort to direct the interested reader's attention to works that are meaningful and that themselves have extensive bibliographies, as well as to provide for the reader sources pertaining to diverse cultural modes in which the cosmic is integral.

Allport, Gordon. *Becoming.* New Haven: Yale University Press, 1960.

Anspacher, Louis. *Challenge of the Unknown.* New York: Wynn, 1947.

Appleton, L.H. *American Indian Design and Decoration.* New York: Dover, 1971.

Argüelles, José. *Charles Henry and the Formation of a Psychophysical Aesthetic.* Chicago: University of Chicago Press, 1972.

Argüelles, José, and Arguelles, Miriam. *Mandala.* Berkeley and London: Shambala, 1972.

Aubert, Marcel. *The Art of the High Gothic Era.* New York: Greystone Press, 1966.

Aurobindo, Sri. *The Life Divine.* New York: Dutton, 1949.

——. *The Human Cycle.* New York: Dutton, 1950.

——. *The Future Evolution of Man.* Pondicherry: Sri Aurobindo Ashram, 1963.

Avalon, Arthur (Sir John Woodroffe). *The World as Power.* Madras: Ganesh, 1966.

Babbit, Edwin. *Principles of Light and Color.* New Hyde Park: University Books, 1967.

Barker, Virgil. *Realism to Reality in Recent American Painting.* Lincoln: University of Nebraska Press, 1959.

Baynes, H.G. *Mythology of the Soul.* London: 1940.

Biederman, Charles. *Art as the Evolution of Visual Knowledge*. Red Wing, Minn.: Art History Publishers, 1948.

Binyon, Laurence. *Painting in the Far East*. New York: Dover, 1959.

Birren, Faber. *Color Psychology and Color Therapy*. New Hyde Park: University Books, 1961.

———. *Color: A Survey in Words and Pictures*. New Hyde Park: University Books, 1963.

Bourdeaux, Edmond S. *The Soul of Ancient Mexico*. San Diego: Academy of Creative Living, 1968.

Bô Yin Râ. *Aus meiner Malerwerkstatt*. Basel: Kober, 1932.

———. *Das Reich der Kunst*. Basel: Kober, 1933.

Bragdon, Claude. *The Eternal Poles*. New York: Knopf, 1931.

———. *The Arch Lectures*. New York: Creative Age Press, 1942.

Brightman, E.S. *The Spiritual Life*. Nashville: Abingdon-Cokesbury, 1942.

———. *Nature and Values*. Nashville: Abingdon-Cokesbury, 1945.

Bru, Charles-Pierre. *Esthetique de l'Abstraction*. Paris: Universitaires de France, 1955.

Brzostoski, John. *Tibetan Art*. New York: The Riverside Museum, 1963.

Burckhardt, Titus. *Sacred Art in East and West*. London: Perennial Books, 1967.

Burrows, Carin. *Tibetan-Lamaist Art*. New York: Henri Kamer Gallerie, Inc., 1970.

Cammann, Schuyler. "The Suggested Origin of the Tibetan Mandala Paintings," *Art Quarterly*, Spring, 1950.

Caso, Alfonso. *Aztecs: People of the Sun*. Norman: University of Oklahoma Press, 1967.

Caudwell, Christopher. *Illusion and Reality*. London: Lawrence & Wishart, 1950.

Cheney, Sheldon. *Men Who Walked with God*. New York: Knopf, 1945.

———. *Expressionism in Art*. New York: Liveright, 1962.

Cirlot, J.E. *A Dictionary of Symbols*. New York: Philosophical Library, 1962.

Coomaraswamy, Ananda K. *Christian and Oriental Philosophy*. New York: Dover, 1956.

———. *The Transformation of Nature in Art*. New York: Dover, 1956.

Covarrubias, Miguel. *Indian Art of Mexico and Central America*. New York: Knopf, 1957.

Critchlow, Keith. *Order in Space*. London: Thames and Hudson, 1969.

Dasgupta, S.N. *Fundamentals of Indian Art*. Bombay: Bharatiya Vidya Bhavan, 1954.

Delacroix, Henri. *Psychologie de l'Art*. Paris: F. Alcan, 1927.

Dember, William N. *The Psychology of Perception*. New York: Holt, 1960.

Dewey, John. *Art as Experience*. New York: Putnam, 1934.

Dixon, W.M. *The Human Situation*. London: Longmans, 1937.

Edman, Irwin. *Four Ways of Philosophy*. New York: Holt, 1937.

Eisler, R. *Worterbuch der Philosophischen Begriffe*. Berlin: Mittler und Sohn, 1904.

Eliade, Mircea. *Cosmos and History*. New York: Harper, 1959.

Elsen, Albert. "Living Art from a Dying Profession," *Journal of Aesthetics and Art Criticism*, June, 1960.

Encyclopedia of World Art. London: McGraw-Hill, 1963.

Evans-Wentz, W.Y. *Tibetan Book of the Dead*. London: Oxford University Press, 1960.

———. *The Tibetan Book of the Great Liberation*. New York: Oxford University Press, 1968.

Fleming, William. *Art and Ideas*. New York: Holt, Rinehart & Winston, 1955.

Focillon, Henri. *The Art of the West in the Middle Ages*. New York: Phaedon, 1963.

Frankl, Victor. *Man's Search for Meaning.* New York: Washington Square Press, 1969.

Fry, John Hemming. *The Revolt Against Beauty.* New York: Putnam, 1934.

Garrett, Eileen J. *Does Man Survive Death?* New York: Helix, 1957.

Gaskell, G.A. *A Dictionary of All Scriptures and Myths.* New York: Julian, 1960.

Giedeion-Welcker, Carola. *Contemporary Sculpture.* New York: Wittenborn, 1955.

Gilbert, Katherine E., and Kuhn, Helmut. *A History of Esthetics.* Bloomington: Indiana University Press, 1953.

Gilles, René. *Le symbolisme dans l'art religieux.* Paris: La Colombe, 1961.

Gimpel, Jean. *The Cathedral Builders.* New York: Grove, 1961.

Govinda, Lama Anagrika. *Art and Meditation.* Allahabad: Allahabad Block Works, 1936.

———. *Foundations of Tibetan Mysticism.* London: Rider, 1960.

———. *The Psychological Attitude of Early Buddhist Philosophy.* New York: Weiser, 1970.

Gray, Christopher. *Cubist Aesthetic Theories.* Baltimore: Johns Hopkins Press, 1953.

Gregory. R.L. *Eye and Brain: The Psychology of Seeing.* New York: McGraw-Hill, 1966.

Griswold, A. K. *The Art of Burma, Korea, Tibet.* New York: Graystone, 1968.

Grombrich, S. *Art and Illusion.* New York: Pantheon, 1959.

Guggenheimer, Richard. *Sight and Insight.* New York: Harper, 1945.

———. *Creative Vision.* New York: Harper, 1960.

Hall, Edward. *The Hidden Dimension.* New York: Doubleday, 1969.

Hall, Manly P. *The Secret Teachings of All Ages.* Los Angeles: Philosophical Research Society, 1947.

Harkness, Georgia. *Conflicts in Religious Thought.* New York: Harper, 1949.

Harold, Preston, and Babcock, Winifred. *The Single Reality.* New York: Dodd Mead, 1971.

Henri, Robert. "The Art Spirit," *Art Digest,* March 1, 1931.

Hocking, William Ernest. *Preface to Philosophy.* New York: Macmillan, 1946.

Hodson, Geoffrey. *The Kingdom of the Gods.* Madras: Theosophical Publishing House, 1952.

Jaspers, Karl. *Reason and Antireason in Our Time.* New Haven: Yale University Press, 1959.

Jinarajadasa, C. *Art as Will and Idea.* Madras: Theosophical Publishing House, 1927.

Jonsson, Einar. *Myndir.* Reykjavik: National Einar Jonsson Museum, 1925.

———. *Skodanir: My Philosophy.* Translated by Richard Beck. Reykjavik: National Einar Jonsson Museum, 1944.

Jung, Carl G. *The Collected Works of C.G. Jung,* 14 vols. New York: Bollingen, 1953.

———. *Man and His Symbols.* New York: Doubleday, 1964.

———. *Psyche and Symbol.* New York: Doubleday Anchor, 1958.

———. *The Undiscovered Self.* New York: Mentor, 1959.

Kahler, Erich. *Man the Measure.* New York: Braziller, 1956.

Kandinsky, W. *Concerning the Spiritual in Art.* New York: Wittenborn, 1948.

Karagulla, Shafica. *Breakthrough to Creativity.* Los Angeles: DeVorss, 1967.

Katz, Leo. *Understanding Modern Art,* 3 vols. Chicago: Delphian Society, 1936.

Kepes, Gyorgy, ed. *Structure in Art and Science.* New York: Braziller, 1965.

Khantipalo, Bhikku. *The Wheel of Birth and Death.* Kandy: Buddhist Publications Society, 1970.

Kootz, Samuel M. *New Frontiers in American Painting*. New York: Hastings, 1943.

Lamouche, André. "Esthétique," in *La Théorie Harmonique*. Paris: Dunod, 1961.

Langer, Susanne. *Feeling and Form*. New York: Scribner's, 1953.

———. *Problems of Art*. New York: Scribner's, 1957.

———. *Reflections on Art*. Baltimore: Johns-Hopkins, 1958.

Leadbeater, C.W. *Thought Forms*. Wheaton: Theosophical Publishing House, 1967.

Leon-Portilla, Miguel. *Aztec Thought and Culture*. Norman: University of Oklahoma Press, 1963.

Lesser, George. *Gothic Cathedrals and Sacred Geometry*, 3 vols. London: Tiranti, 1957-1964.

Malraux, André. *The Voices of Silence*. Translated by Stuart Gilbert. New York: Doubleday, 1953.

Maluc, Pierre. "Automatic and Mediumistic Drawings," *Revue Métapsychique*, July, 1957.

Micoun, Richard W. *Basic Ideas in Religion*. New York: Association Press, 1916.

Mukerjee, Radhakamal. *The Social Function of Art*. New York: Heinman, 1948.

Nasr, Seyyed Hossein. "Some Metaphysical Principles Pertaining to Nature," *Studies in Comparative Religion*, 14: No. 4, Autumn, 1966.

Northrup, F.S.C. *The Meeting of East and West*. New York: Macmillan, 1946.

Otto, Rudolph. *Mysticism East and West*. New York: Meridian Books, 1957.

Ousley, S.G.J. *Colour Meditations*. London: Fowler, 1949.

Pearson, Ralph M. *The Modern Renaissance in American Art*. New York: Harper, 1954.

Popper, Frank. *Origins and Development of Kinetic Art*. London: Studio Vista, 1968.

Prasad, Rama. *Nature's Finer Forces*. Madras: Theosophical Publishing House, 1933.

Ramsden, E.H. *Sculpture: Theme and Variations*. London: Lund Humpheries, 1953.

Read, Herbert. *Art and Society*. New York: Pantheon, 1945.

———. *Icon and Idea*. Cambridge: Harvard University Press, 1955.

Regamey, P.R. *Art Sacre au XXe Siécle*. Paris: Editions du Cerf, 1952.

Reichard, Gladys A. *Navaho Religion: A Study in Symbolism*. New York: Bollingen, 1963.

Rowley, George. *Principles of Chinese Painting*. Princeton: Princeton University Press, 1947.

Saarinen, Eliel. *Search for Form*. New York: Reinhold, 1948.

Sartre, J.P. *Existentialism and Humanism*. London: Methuen, 1948.

Sastri, K.S.R. *The Indian Concept of the Beautiful*. Travancore: University of Travancore, 1947.

Sawa. *Art of Esoteric Buddhism*. New York-Tokyo: Weatherhill, 1972.

Schuon, Frithjof. *Spiritual Perspectives and Human Facts*. Translated by Macleod Matheson. London: Faber and Faber, n.d.

———. *Transcendent Unity of Religions*. Translated by Peter Townsend. London: Faber and Faber, n.d.

Schwenk, Theodor. *Sensitive Chaos: The Creation of Flowering Forms in Water and Air*. London: Rudolph Steiner Press, 1968.

Sedlmayr, Hans. *Art in Crisis*. Chicago: Regnery, 1958.

Sejourné, Laurette. *Burning Water: Thought and Religion in Ancient Mexico*. New York: Grove, 1960.

Singh, Madanjeet. *Himalayan Art*. New York: Macmillan, 1965.

Smith, E. Baldwin. *The Dome*. Princeton: Princeton University Press, 1950.

Sorokin, Pitirim A. "Three Basic Trends of Our Times," *Triad*, 2: No. 1, 1961.

Soustelles, Jacques. *La pensée cosmologique des anciens mexicains*. Paris: Herman, 1940.

Stapleton, Olaf. "God the Artist," *Contemporary British Philosophy*, vol. II. Edited by John J. Muirhead. London: Macmillan, 1925.

Steiner, Rudolph. *Art in the Light of the Mystery Wisdom*. Translated by Shirley M.K. Gandell. New York: Anthroposophic Press, 1935.

———. *The Nature and Origin of the Arts*. Translated by H. Collison. London: R. Steiner, 1945.

Stites, Raymond S. *The Arts and the Man*. New York: McGraw-Hill, 1940.

Strachey, Lytton. *Books and Characters*. New York: Harcourt Brace, 1922.

Streeter, Burnett H. *Reality*. New York: Macmillan, 1926.

Struppeck, Jules. *The Creation of Sculpture*. New York: Holt, 1952.

Sze, Mai-Mai. *The Way of Chinese Painting*. New York: Vintage, 1959.

Tagore, Rabindranath. "The Religion of an Artist," in *Contemporary Indian Philosophy*. Calcutta: Visva-Bharati, 1953.

Tart, Charles T. *Altered States of Consciousness*. New York: Wiley, 1969.

Thompson, D.W. *On Growth and Form*. New York: Cambridge University Press, 1961.

Thompson, J. Arthur. *The System of Animate Nature*. London: Williams and Norgate, 1920.

Tillich, Paul. "Art and the Ultimate Reality." A lecture given at the Museum of Modern Art, February 17, 1959.

Tinbergen, N. *The Study of Instinct*. London: Oxford University Press, 1951.

Tucci, Guiseppe. *Theory and Practice of the Mandala*. London: Rider, 1960.

Van Der Leeuw, Gerardus. *Sacred and Profane Beauty: The Holy in Art*. New York: Holt, 1963.

Villaseñor, David. *Tapestries in Sand. The Spirit of Indian Sandpainting*. Healdsburg: Naturegraph Press, 1966.

Vogt, Von Ogden. *Art and Religion*. New Haven: Yale University Press, 1948.

Wauer, William. *Das Buch von Ur*. Privately published. 1922–1925.

Weiss, Paul. *Modes of Being*. Carbondale: South Illinois University Press, 1958.

Wheelwright, Philip. *The Burning Fountain*. Bloomington: Indiana University Press, 1954.

White, L.L. *Aspects of Form*. Bloomington: Indiana University Press, 1951.

Whitehead, Alfred N. *Religion in the Making*. New York: Macmillan, 1926.

———. *Adventures of Ideas*. New York: Macmillan, 1933.

Whitmont, Edward C. *The Symbolic Quest*. New York: Putnam, 1969.

Wieman, Henry N. *The Source of Human Good*. Chicago: Chicago University Press, 1946.

Wilhelm, Richard. *Secret of the Golden Flower*. New York: Harcourt, 1931.

Yogananda, Paramhansa. *Autobiography of a Yogi*. Los Angeles: Self-Realization Fellowship, 1958.

Zuckerkandi, Victor. *Sound and Symbol*. Princeton: Princeton University Press, 1969.

INDEX

Air Symphony (Valensi), 50, 52
Albrizio, Conrad A., 2
Allen, Anna H., 8
Alpha (Mahler), 115, 116
And Spirit Moved on the Waters (Graham), 48, 52
And There Was Light (Orogo), 46, 52
Antahkarana (Stowitts), 106
Apex (Maluc), 19
Archipenko, Alexander, 11, 37
Artistic creation:
 function of, 32
 motives for, 45
Ascendent Flame (Harwood), 106
Ascending Self, The (*The Rising Soul*) (Heil), 18
Aspiration (Moore), 92
Assault (Janin), 32–38
Atomic forces, 53, 61, 105, 115
At-One-Ment (Bisttram), 17
Aurobindo, Sri, 104
Aurora Borealis (Wahl), 136
Avatar (Rudhyar), 108, 123
Awareness:
 of future, 15
 of interdependence, 29–30
 psychic, 108
 of self, 38
Awareness (Géla), 11, 12–13

Baele, Stan, 106
Beecher, William Ward, 76
Being (Osen), 78, 80
Beyond the Stars (Harwood), 132, 135
Bhatt, Krishnalal, 38
Biederman, Charles, 44
Bill, Max, 4–5, 11
Birth, 78, 106
Birth of an Idea (Schrack), 32, 35
Bisttram, Emil, 16–17, 30
Black Shape of Madness, The (Haucke), 83
Boner, Alice, 103–104, 134, 135
Brightman, E. S., 4
Britsky, Nicholas, 106, 107
Brothers Karamazov, The (Dostoevsky), 29
Brunner, Elizabeth Farkas, 86, 108

Callahan, Kenneth, 72, 73
Carryin' Life's Burden (Prado), 71, 73
Cary, Clint, 9, 11
Caudwell, Christopher, 40
Chaos, 24
Christ (Ponomarew), 125
Čiurlionis, Mykolas, 32, 33, 34
Clairvoyance, 105
Consciousness, expanding, 106
Cosmic Architecture (Wolf), 91, 92

Cosmic art:
 fundamentals for grasping, 44
 human suffering in, 63–99
 idealism in, 23
 introspectiveness in, 45–51
 origins of, 1–20
 to portray interdependence, 21–62
 reality in, 29, 43–45, 61, 63–99, 103, 105
 responses to, 40
 transcendentalism in, 10, 23, 29, 38, 40, 45, 73, 98,
 101–139
Cosmic artists, goals of, 15
Cosmic Beginning. Death—Darkness to Light
 (Brunner), 86
Cosmic Consciousness (Mideros), 53, 60
Cosmic Mother (Prado), 52, 58
Cosmic Presence (Davis), 139
Cosmic relationships, 29–30
Cosmic Visitors #4 (Ino), 115, 129
Cosmic Visitors #5 (Ino), 115, 129
Cosmic World (Mehra), 133, 135
Cosmos, defined, 24, 30
Creation, 11, 38, 52, 135
Creation (Jaeckel), 109
Creative Evolution (Boner), 134, 135
Creative Forces (Bisttram), 30
Crucifixion, 65
Cubism, 44

Davis, Emma Lu, 139
Dead End (Beecher), 76
Death, 65, 68, 78, 92, 106
Death (Baele), 106
Death (Peavy), 78, 85
"*Death*" (Peavy), 84
Death (*Disincarnation*) (Mulac), 86, 92
Déchéance: Death and Resurrection (Ino), 89, 92
Delacroix, Henri, 45
Deliverance (Jonsson), 97
Disincarnation (*Death*) (Maluc), 86, 92
Divine Omnipotence (Osen), 38
Dostoevsky, Fyodor, 29
Dottori, Gerardo, 38, 42, 43, 53, 108
Doux, Jean Picart le, 137
Duren, Terrence, 64
Dynamism of the World (Dottori), 42, 53

Einstein, Albert, 10, 115
Enchainment (Janin), 16
End of Humanity, The (Frugès), 68, 93
Essence (Jonsson), 11, 14
Evil, portraying, 63–99
Evolution (Jaeckel), 110
Exaltation (Archipenko), 37

Farleigh, John, 78, 87
Fear (Murphy), 73, 81
Feininger, Lyonel, 10
Flight over the Ocean (Dottori), 38, 108
Floating Shapes #2 (Britsky), 106, 107
Flower, The (Radaelli), 49
Fluorescent pigments, 11
Form-symbols, paintings as, 11, 38
Fosdick, Harry Emerson, 68
Fragment of a World (Dottori), 38
Frughès, Henri, 68, 69, 74, 78, 93
Future, awareness of, 15
Future (Pelton), 28, 32

Géla, 11, 12–13
Geometric forms, 11, 106
Germs of Inspiration (Schrack), 39
Glorious Perception (Cary), 9, 11
God the Father (Ponomarew), 126
God of the South Pacific. A (Quail), 108, 122
Gods, The (Radaelli), 49, 51
Gold (Wahl), 75
Golden Purusha, The (Bhatt), 38
Graham, George, 47, 48, 52
Graves, Morris, 6–7, 11, 66, 73
Gray, Christopher, 44
Groping (Moore), 67, 73
Guardian of the Planet (Perkins), 52, 56

Harwood, Ruth, 106, 132, 135
Haucke, Frederick, 78, 79, 83
Heil, Joseph, 18, 69
Heisenberg, Werner, 115
Hocking, William Ernest, 29
Hoff, Margo, 44
Hoffman, Hans, 45
Holy Spirit (Ponomarew), 127
Human Realm, The (Krebs), 106
Human suffering, 63–99
Humor, cosmic, 115

Idealism, in cosmic art, 23
Idol of America (Moore), 92
Illumination (Jaeckel), 111
Illumination (Pelton), 25
In the House of the Lord Forever (Wilde), 52, 54
In My End Is My Beginning (Farleigh), 78, 87
Individual State of the World, The (Graves), 66, 73
Ino, Pierre, 89, 92, 115, 129
Interdependence, universal, 21–62
 awareness of, 29–30
Introspectiveness, 45–51
Intuition, defined, 43
Isabel of Castille (Janin), 38

Jaeckel, Willy, 109, 110, 111
Janin, Louise, 16, 32–38, 119, 130
Jonsson, Einar, 11, 14, 15, 96, 97, 106

Karma, law of, 68
Katz, Leo, 68, 94, 115, 128
Kimball, Maulsby, 92, 98
Krebs, Columba, 106

Lafon, Jean, 106, 108
Landscape (Albrizio), 2
Laurence, William, 115
Life, Death, and Transfiguration (Starr), 90
Lo, Here Am I (Sims), 73, 82

Machine age, 73, 92
McNeur, Lynda, 44
Magnitude (Mahler), 108, 118
Mahler, Sylvia Leone, 65, 96, 99, 108, 115, 116, 117, 118
Malraux, Andre, 10, 44
Maluc, Pierre, 19, 86, 92
Man, Time, and the Machine (Callahan), 72, 73
Man Inherits the Earth (Duren), 64
Man and the Universe (Doux), 137
Man's Search for Reality (Mullen), 52–53, 57
Manso, Leo, 45
Marbrook-Guccioni, Juanita, 73, 88
Marriage of Fire and Water, The (Janin), 130
Martin, Margaret E., 108, 131
Meditation (Brunner), 108
Mehra, Parmanand S., 133, 135
Memoria in Aeterna (Molzahn), 31
Meštrović, Ivan, 10, 69, 70, 73, 138
Metamorphosis 1942 (Katz), 68, 94
Mideros, Victor, 53, 60
Miles, Jeanne, 36, 38
Molzahn, Johannes, 30–31
Moore, Philip, 67, 73, 92, 96
Morning (Jonsson), 106
Morning of Creation, The (Graham), 47, 52
Morning Stars Sang Together, The (Vilas), 53, 59
Mother (Sloan), 106, 112
Mullen, Buell, 52–53, 57, 102, 105
Mur du Monde, Le (*The Wall of the World*) (Lafon), 106, 108
Murphy, Alice Harold, 73, 81
Musicalism, 52

Necromancy and Nativity (Vilas), 106
New York Times, the, 115

Omega (Mahler), 115, 117
Orbits (Pelton), 26, 32

Order, spatial, 11, 24, 61
Orogo, Michael, 46, 52
Osen, Erwin Dom, 38, 78, 80

Peavy, Paulina, 78, 84–85
Pelton, Agnes, 22, 24, 25–28, 32
Penalty of Genius, The (Sloan), 77
Perception, defined, 43
Perkins, Philip, 52, 55, 56
Phrenic Universe (Haucke), 78, 79
Plastic art, 45
Plastics, as art medium, 11
Pliny, 24
Poetic image, in art, 92
Poets and poetry, 10, 52, 61, 84, 114, 119, 131
Polyester Sphere #2 (Miles), 36
Ponomarew, Serge, 40, 115, 124–127
Portrait of William Laurence, Science Editor of the New York Times (Katz), 115, 128
Prado, Marina Nuñez del, 52, 58, 71, 73
Presence (Wolf), 108, 120
Prophecy, 115
Psychic transcendentals, 104

Quail, Ethelwyn M., 108, 122

Radaelli, Mario, 49, 51
Radiation (*Sun Center for Meditation*) (Allen), 8
Reality, 29, 63–99, 103, 105
 recognizing, 43–45, 61
Redemption (Mahler), 65, 99
Reiser, O. L., 30
Release (Martin), 108, 131
"Release" (Martin), 131
Remy, Reva, 95
Rex (Ciurlionis), 32, 34
Rising Soul, The (*The Ascending Soul*) (Heil), 18
Rudhyar, Dane, 108, 123

Schrack, Joseph Earl, 32, 35, 39
Science, view of nature, 15
Self:
 awareness of, 38
 definitions of, 4
Semi-abstract art, 105
Sense experiences, 23, 29, 45, 92, 105
She Had Many Faces (Marbrook-Guccioni), 73, 88
Sims, Charles, 73, 82
Sloan, Blanding, ii, 77, 96, 106, 112, 113, 114
Social transcendentals, 104
Sonata of the Sun (Ciurlionis), 32, 33
Sorokin, Pitirim A., 105
Space, man's concept of, 3–4
Spiritual Gestation, Struggle for Light (Remy), 95

Star Gazer (Pelton), 22
Starr, Lorraine, 90
Stowitts, Hubert, 106
Subliminal transcendentals, 104, 108
Suffering, human, 63–99
Sun Center for Meditation (*Radiation*) (Allen), 8
Supplication (Městrović), 70, 73
Surrealism, 68
Symbolism, 11, 24, 30, 38, 40, 45, 51, 52, 73, 78, 108

Telepathy, 105
Thinking, defined, 43
Tillich, Paul, 4
Time, man's concept of, 3–4
Towards an Archetypal Anatomy of the Soul (Zimmerman), 108, 121
Transcendentalism, 10, 23, 29, 38, 40, 45, 73, 98, 101–139
Transformation (Bhatt), 38
Trial by Fire (Kimball), 92
Trinity (Ponomarew), 115, 124–127
Truth, as self-contact with reality, 45
Two Infinities; Expanding and Vanishing (Sloan), ii

"Unanswered Question, The" (Janin), 119
Universal Kingdom, The (Krebs), 106
Universal linkage, 29–30
Unlimited and Limited (Bill), 4–5, 11

Valensi, Henry, 50, 52
Value transcendentals, 104
Van Dooren, Edmond, 52, 55
Vilas, Faith, 53, 59, 61, 106
Vortices of Outer Space, The (Krebs), 106

Wahl, Bernard O., 75, 136
Walk through the Gates (Sloan), 106, 113
Wall of the World, The (*Le Mur du Monde*) (Lafon), 106, 108
War (Frughès), 74, 78
Watercolor, 92
What does it now pillar apart? (Graves), 6–7, 11
Wilde, Victor de, 52, 54
Winged Eye, The (Van Dooren), 52, 55
Wolf, Gustav, 91, 92, 108, 120, 138

Youth Seeks the Far Galaxies (Mullen), 102, 105

Zimmerman, Helmut, 108, 121

ABOUT THE AUTHORS

RAYMOND F. PIPER, Ph.D., was born on a farm in Wisconsin in 1888. In 1929, while professor of philosophy at Syracuse University, he reinstated a course on aesthetics, which had been abandoned in 1893. His interests in human metaphysical values were deeply rooted. During vacations and sabbaticals he traveled extensively, absorbing the cultures of India, Japan, China, and the Near East, as well as studying modern movements in aesthetics and philosophy in Europe and the United States. From the time he graduated from the Harvard Divinity School until his death in 1961, his curiosity about contemporary metaphysical art throughout the world developed far in advance of contemporary conceptions of the psychic, the religious, and the metaphysical in art. His correspondence inspired hundreds of artists throughout the world, and established him during his lifetime as perhaps the only authority in this hitherto mysterious and esoteric field. He wrote countless papers and articles on this and on other topics, was coauthor, with Paul Ward, of the basic philosophy textbook, *The Fields and Methods of Knowledge*, and, with William P. Tolley and Ross E. Hoople, helped to write *Preface to Philosophy*. This present volume, published posthumously, represents a summary of his vast researches into modern metaphysical awareness on a worldwide basis, as expressed by living artists.

LILA K. PIPER, Ph.D., is considered, by the thousands of people who know her, to be an outstanding humanitarian, who has devoted her life to helping others. Coming also from America's Midwest, she was born in 1896 in Iowa. She met Raymond Piper in 1933, in Darjeeling, India, where, for years, she had been principal of the Mount Herman School. After their marriage, they settled in Syracuse, New York. During World War II, she was director of the War Council of Volunteers Center, as well as New York state director of the War Council Child Care Division. Because of her empathy for the youth of the world, she makes her home available to international exchange students studying at Syracuse University, as well as guiding and heading countless girl's clubs. At present she is president of the American Association of Retired Persons at Syracuse, travels and lectures widely, and finds time annually to make by hand thousands of decorative items, which are sold to help support her local church. She is a master graphoanalyist, and has received two of their highest honors from the International Graphoanalyist Society. Her interest in metaphysical and inspired art never flagged behind that of her late husband and, with him, she opened her home for three decades to artists from all over the world, interviewing them, and helping her husband to produce this volume.

INGO SWANN, born in 1933 in Colorado, is an artist and parapsychologist now living in New York. Trained as a biologist, his own interests in the advancing frontiers of experience and knowledge led him first to a position at the United Nations, which he held for many years. He then shifted his attention to the psychic and paranormal potentials he believes are inherent in everyone. He made a name for himself in parapsychological research while working with various leaders in that field at the City College of New York, at the American Society for Psychical Research, and at Stanford Research Institute. He is currently involved in several ongoing research programs in this field, a good deal of which is reported in his book, *To Kiss Earth Good-bye*. In 1967, Mr. Swann's deep interest in modern metaphysical and psychic aspects of contemporary art led Lila Piper to give him Raymond Piper's complete research collection on art, a mass of papers that filled twelve egg crates. It was out of this astonishing collection that he worked with Lila Piper to prepare this book.